MW00780821

IMPRESSIONS OF
PARIS

IMPRESSIONS OF
PARIS
an artist's sketchbook

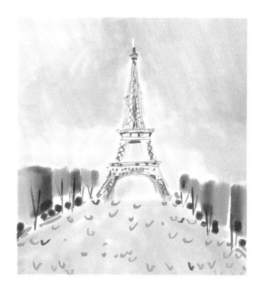

CAT SETO

HARPER
DESIGN

An Imprint of HarperCollins Publishers

FOR THE CITY OF LIGHT,
AND FOR NOLAN,
THE LIGHT OF MY CENTER

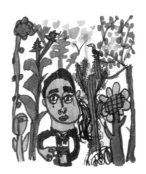

Portrait of Mom in
the botanical gardens
by Nolan Chu

CONTENTS

INTRODUCTION

*"I've seen you, beauty, and you belong to me now,
whoever you are waiting for, and if I never see
you again, I thought. You belong to me and all
Paris belongs to me and I belong to this notebook
and this pencil."*—ERNEST HEMINGWAY

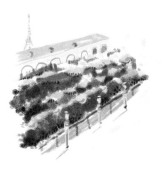

My first visit to Paris happened late in life when I was
feeling a bit creatively burned-out and thought a trip might
provide some stress relief. I fell asleep with my head against
the window of the taxi on the way into the city and
awoke to an intimacy of color, architecture, and detail I
had never known before. Little did I know when the taxi
suddenly turned onto the Place de la Concorde, with
my hands pressed against the glass, that I was beginning
a transformative journey of curiosities and visual delights.
And that I would be forever changed and connected
to the city as an artist and designer.

COLOR

**Four qualities define
the essential properties of color:
hue, intensity, value, and tint.
Hue names the color, while
intensity or saturation defines the
depth of vividness. Value defines
light and darkness, and tint is a
calibration of how much value
is attributed to a color.**

Visiting Paris changed my color palette for life. Color resonates here in the only way it can in a city with such vast history and culture—it is not found on the surface but lifts up from within its surroundings. I had never experienced pockets of color in such a way as through the lacquered doors and storefronts framed by stone walls, glimmering lip colors of chic Parisiennes, or through the endless confections found through the city's patisseries and chocolatiers.

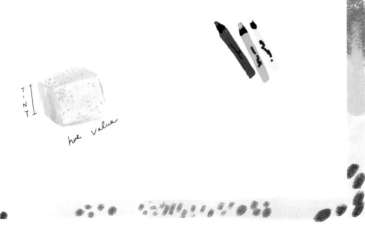

TINT

hue value

BERTHILLON

29-31 Rue Saint-Louis en L'île | 75004

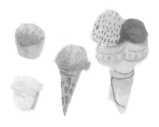

"Color is my day-long obsession, joy, and torment."
—CLAUDE MONET

I am in vehement agreement, Mr. Monet, but with one addition . . . so is ice cream. Berthillon dominates the Île Saint-Louis, where even city natives queue down the street for the ceremonious glaces. It was in this queue that I had many moments to spy the bins filled with their daily offerings. I tasted the pistache and poire. I can only explain that when you lay down a good oil or watercolor tint you can literally feel the purity of the color wash onto canvas. The artful glaces did just that to my mouth.

BERTHILLON

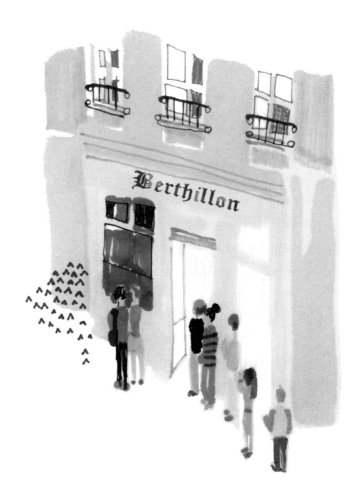

deconstructed ice cream bits:

- pistache
- citron vert
- mandarine
- cassis
- melon
- fraise
- ananas
- vanille
- chocolat mendiant
- caramel
- chocolat noir
- caramel
- praline
- pignons
- moka café
- noix de coco

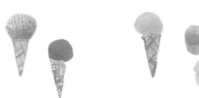

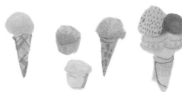

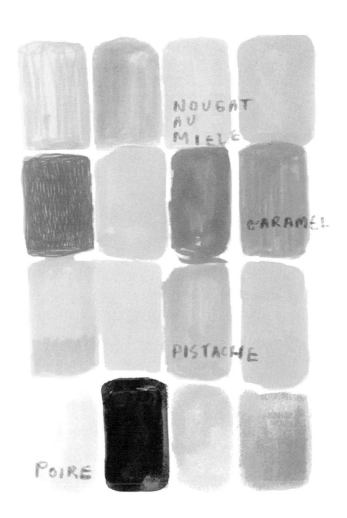

NOUGAT AU MIEL

CARAMEL

PISTACHE

POIRE

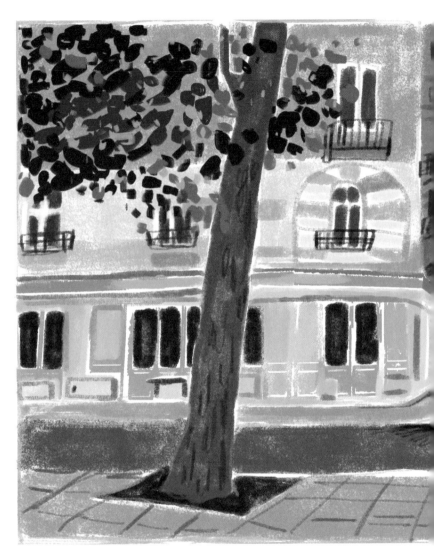

CANAL SAINT-MARTIN

Boulevard Richard-Lenoir | 75011

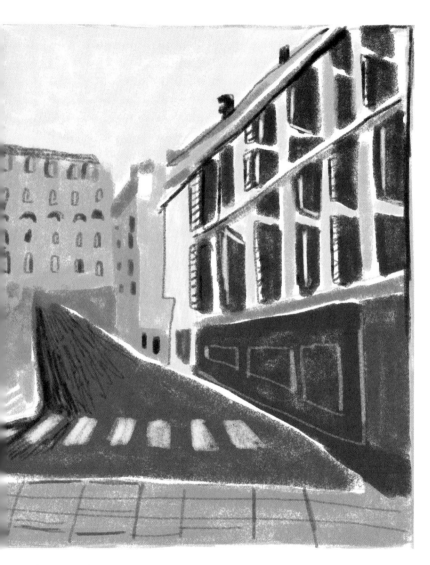

This pop of turquoise brought such joy to my sketchbooks as I spent
an afternoon wandering down Canal Saint-Martin. The many splendors
and beautiful surprising bursts of color found in the city are so remarkable
to me—this could be any corner shop in the city.

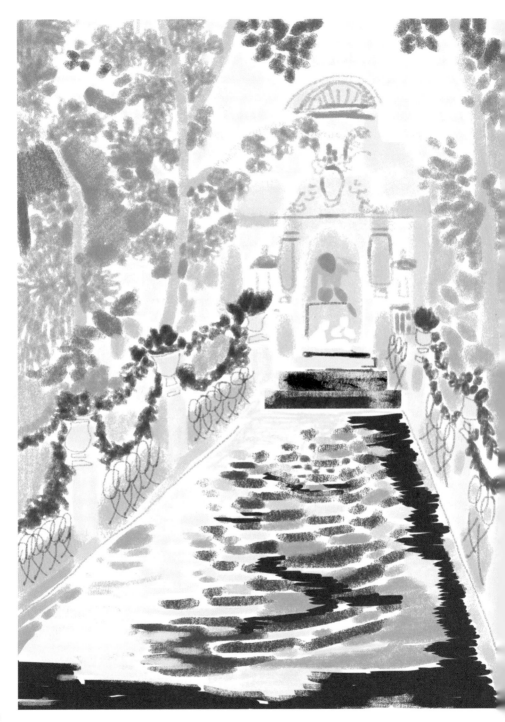

pistate elm mint seapass aloe

THE MEDICI FOUNTAIN

Jardin du Luxembourg | 75006

Here is the most verdant and intimate fountain within
the Luxembourg Gardens. It is dense and intimate,
inspiring an interplay of green-dappled colors.

ARTY DANDY

1 Rue de Furstemberg | 75006

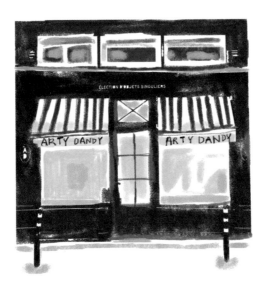

Parisian storefronts are wonderful examples of contrast,
as they are often painted in deep or bold layers of color.
Some of my favorite types are simply black-and-white,
but this combination can take on a dramatic effect,
especially at night, when the shop glows from within.

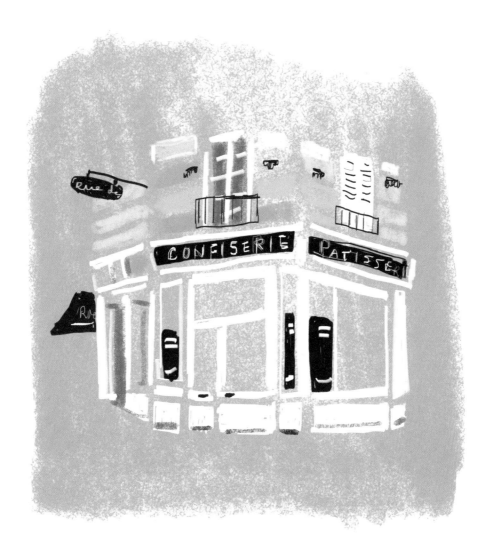

PÂTISSERIE BOULANGERIE BORIS

The shops on Rue Caulaincourt | 75018

LADURÉE
21 Rue Bonaparte | 75006

Perfumed. Pastel. Perfection. The
Ladurée macaron is always my last
memory of Paris when I depart, as I
hoard boxes of them in my suitcase.
The macarons are displayed in
chalky tones: bright like the citron
and chocolate cherry and the
more muted pistachio and spice.

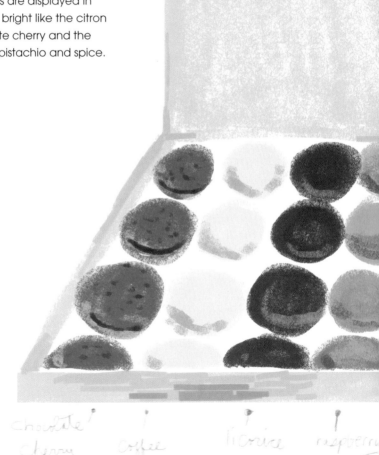

chocolate
cherry coffee licorice raspberry

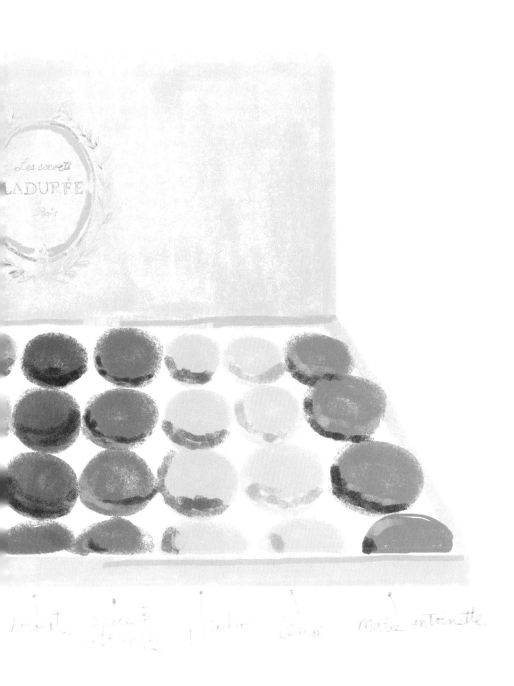

Les secrets
LADURÉE
Paris

MERCI

111 Boulevard Beaumarchais | 75003

This bright little red Mini was the first thing that caught my eye when I visited Merci. It sits at the entrance and has become the loving mascot of this brilliant design concept shop. If you are a design and color nerd like I am, then you are sure to find delight in the bubblegum notebooks, rainbow-hued *washi* tape, and other paper goods.

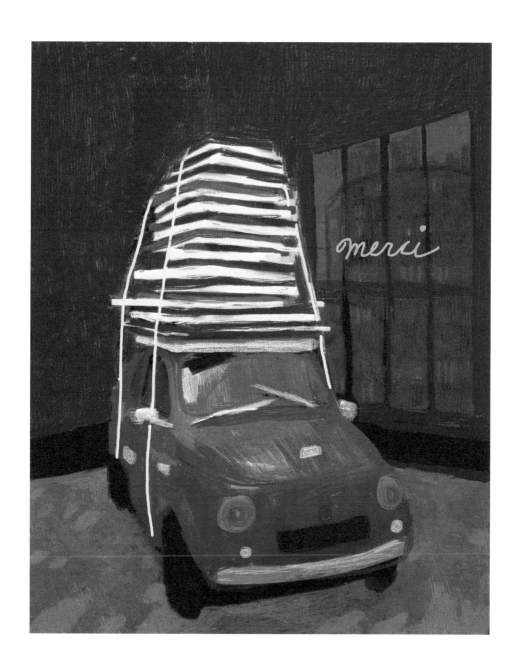

I am always reminded of all the virtues of a Frenchwoman's style, with these in particular: let your hair be au naturel, and the less product the better, EXCEPT for lipstick. The brighter the better.

PAINTED DOORS

My favorite painted doors in the city
are the bold jewel-toned doors that hint
at the courtyards within. I love glimpsing
areas of weathered patina or a shiny
medallion brushed in emerald.

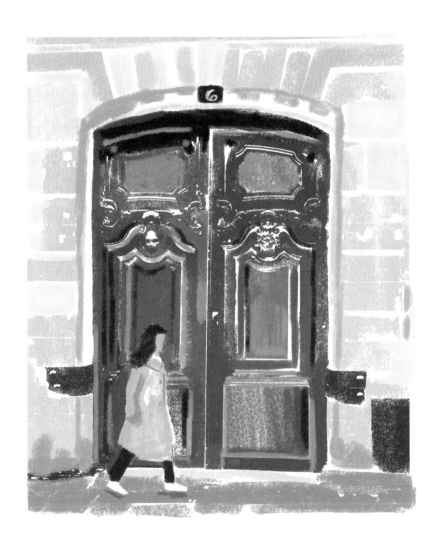

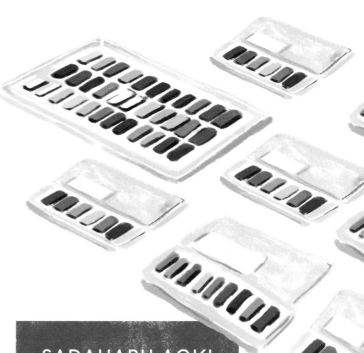

SADAHARU AOKI

35 Rue de Vaugirard | 75006

This patisserie by Japanese chef patissier Sadaharu Aoki contains some of the most delectably created sweets. I thought I was glimpsing a tray of primary-colored Pantones when I encountered these minimalist ganaches and could not bear to eat any because of their beauty. The sleek and delectable design of the cakes inspire many a pattern. . . .

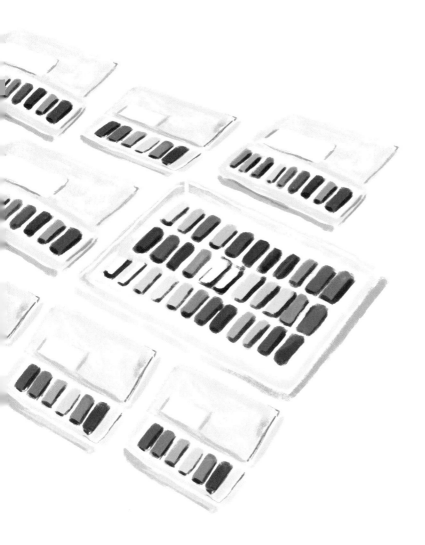

SENNELIER

3 Quai Voltaire | 75007

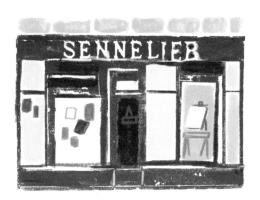

This has been an artists' haven for more than a century. Thick, vibrant oil pastels dot the chestnut wood walls and dare whisper the secrets of some of its timeless patron masters: Cézanne, Picasso, and van Gogh, to name a few.

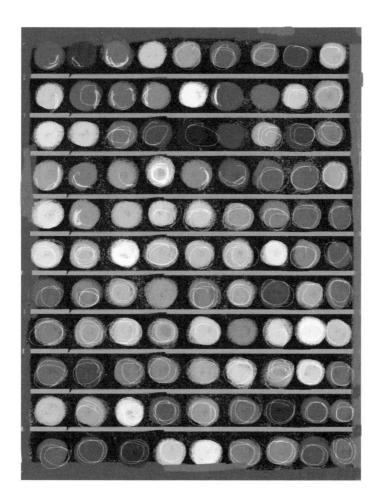

JACQUES GENIN

133 Rue de Turenne | 75003

Warm caramels. Jellies set amid a whitewashed exterior. Minimalist counters and tin metal packaging: This is the world of Jacques Genin and a wonderful example of marrying warm and cool color palettes. Genin's warm mango caramels are one of the star vivants of the shop, but I will always buy a handful of his jellies to keep in my satchel for when my sweet tooth beckons.

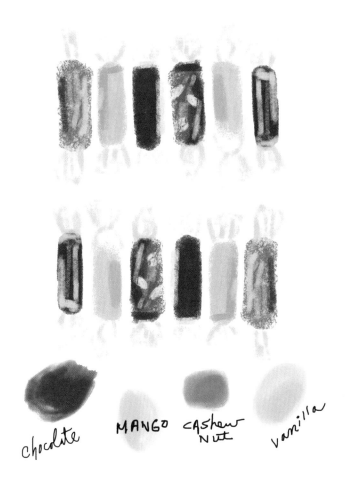

chocolate MANGO cAshew Nut vanilla

PÂTES DE FRUITS

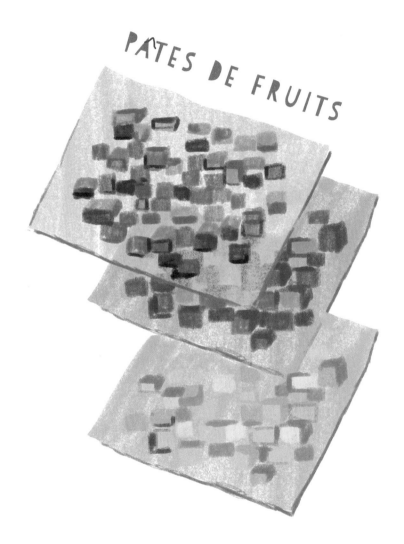

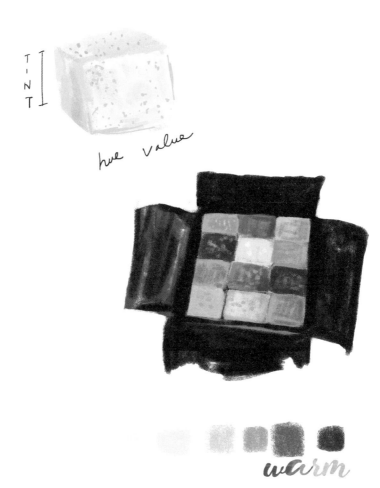

TINT

hue value

warm

SEINE RIVER AT SUNSET

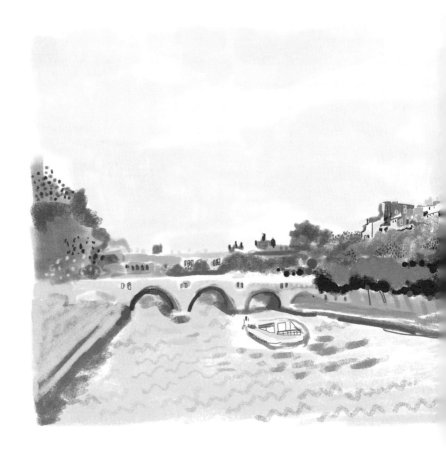

blush

frost

suede

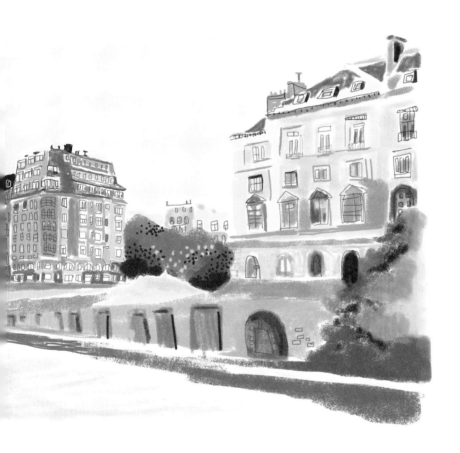

jade

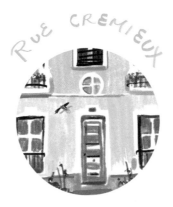

This was on my list of secret streets, as it is a very small corridor that can almost be missed while walking past it. The terraced houses line the cobbled street in remarkable Easter-like pastel shades. Even more charming are the trompe l'oeil paintings on the homes, some of which depict a curious cat, birds in flight, or a twisting palm.

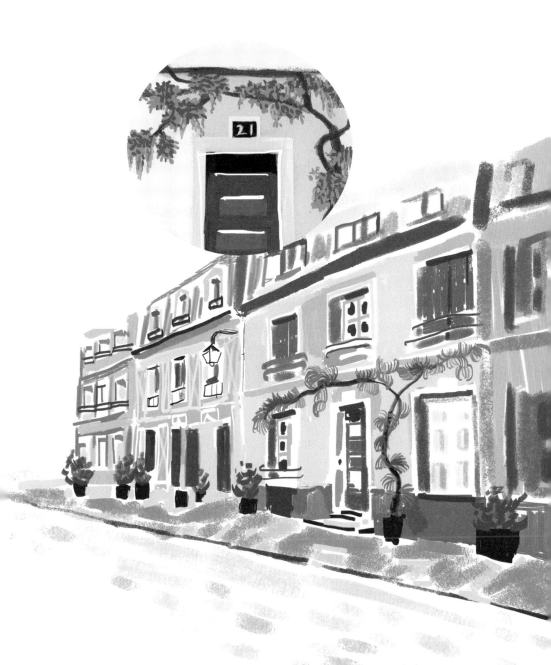

PATTERN

A shape, object, or element
repeated in a predictable
manner. Patterns can be found
in exacting forms from geometry
or organic formations found
in nature, such as a spiral or
water currents.

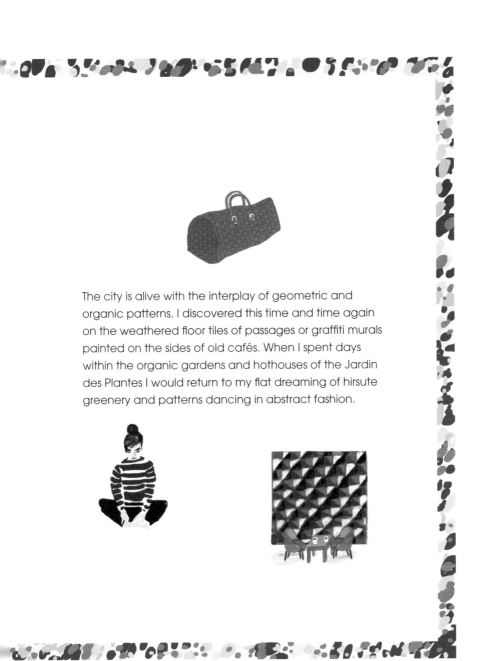

The city is alive with the interplay of geometric and organic patterns. I discovered this time and time again on the weathered floor tiles of passages or graffiti murals painted on the sides of old cafés. When I spent days within the organic gardens and hothouses of the Jardin des Plantes I would return to my flat dreaming of hirsute greenery and patterns dancing in abstract fashion.

LA MANUFACTURE DE CHOCOLAT
ALAIN DUCASSE

40 Rue de la Roquette | 75011

These are the industrially chic inner workings of master
Alain Ducasse. Inside the shop is a single glass table
with a curved glass dome, which is lifted to procure
the chocolates. The cocoa beans are roasted on-site
to perfect the craftsmanship in the artisanal
chocolate making.

RIGHT: Under a mini glass dome one of the signature bars, the
Mendiant, caught my eye; it displayed the loveliest pattern of
dancing almonds, candied oranges, and figs.

NEXT PAGE: A wall of golden boxes divides the shop from the
studio. It could easily be mistaken for a wall of luxury handbags.

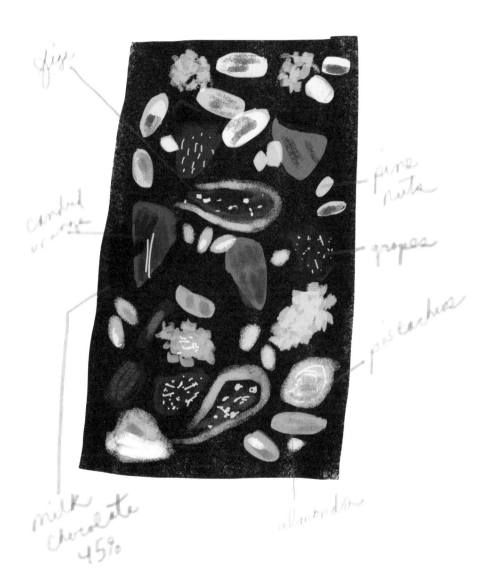

figs

pine nuts

candied orange

grapes

pistaches

milk chocolate 45%

almonds

37

LE CHOCOLAT BOX DISPLAY

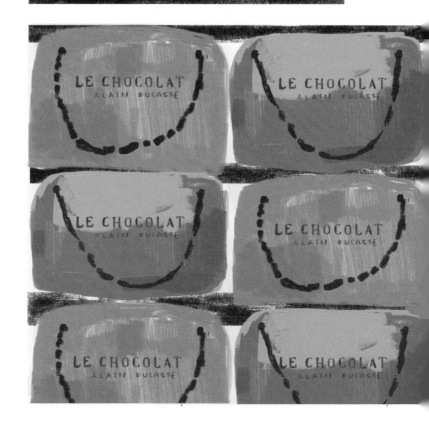

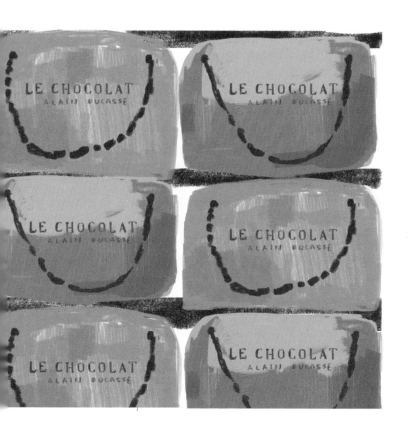

BRETON STRIPE

I could not stop searching for the hint of stripes on the streets. There is something very official about the French stripe, or the "breton." It was first created as a uniform for the French navy. Stripes were a pattern used to contrast against water in case seamen went overboard. What I love is that the original bretons had strictly 21 stripes to represent each of Napoleon's victories.

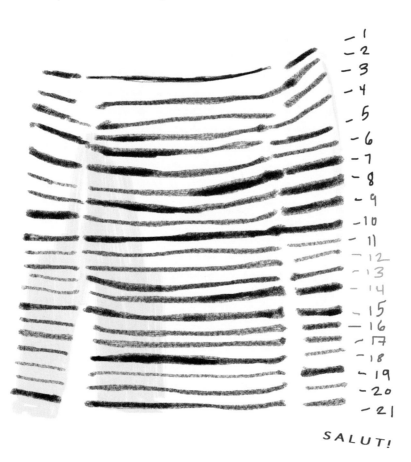

SALUT!

PICASSO

AUDREY HEPBURN

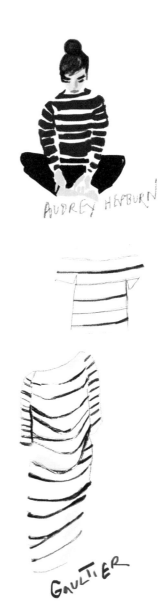

COCO CHANEL

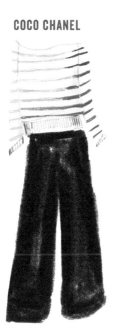

A.P.C.

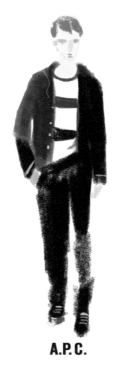

GAULTIER

DU PAIN ET DES IDÉES

4 Rue Yves Toudic | 75010

They say Parisians rarely queue, so when I saw this one curling out of Du Pain et des Idées I had to join. I emerged having had one of the best croissants of my life. And my visual senses were very pleased as well. There were pyramids of baguettes, mini-pavès, and the spiraling pistachio chocolate escargots.

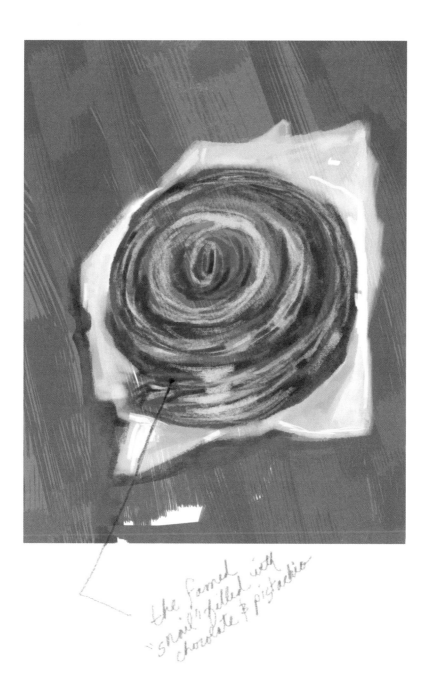

the famed icl
"snail" filled with
chocolate & pistachio

43

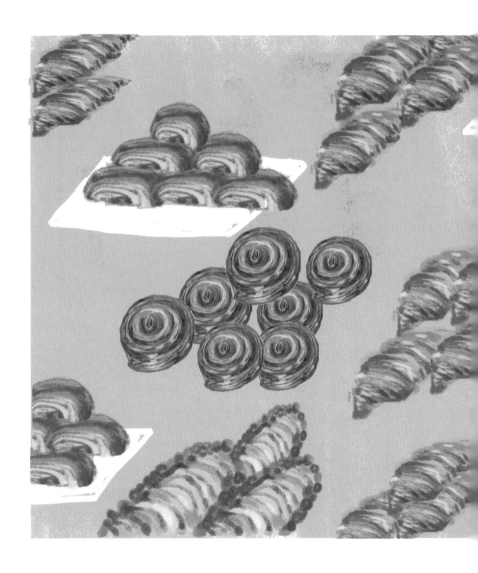

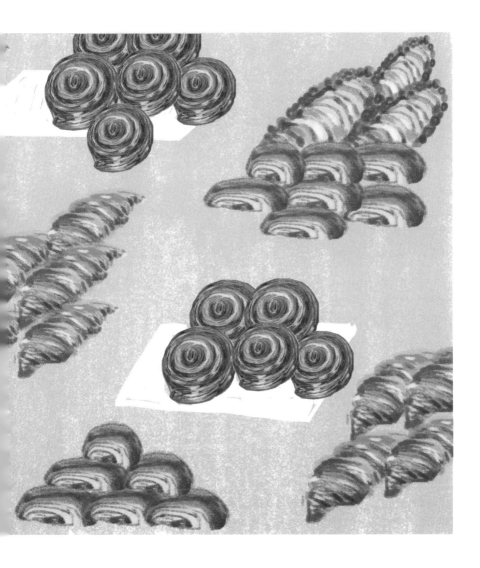

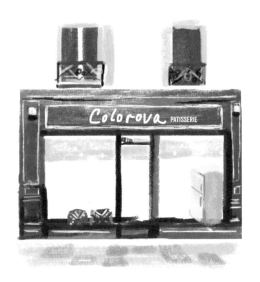

STOREFRONT
47 RUE de
L'ABBÉ GRÉGOIRE

PATTERN
BACK WALL

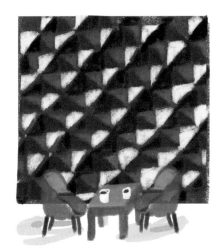

COLOROVA

47 Rue de l'Abbé Grégoire | 75006

The name says it all. The façade is a gunpowder black, which frames the intricate bursts of patterns on textiles within this neo-bakery. I could not stop staring at Tunisian-inspired textile seats and wall hangings while sipping tea. This is truly a merger of Guillaume Gil's technicolor dream of design and food.

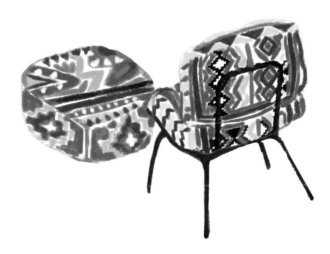

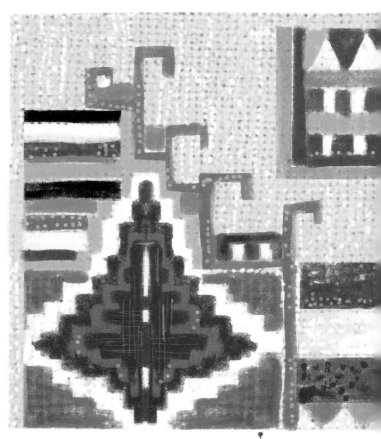

kilim Pattern in Textiles

48

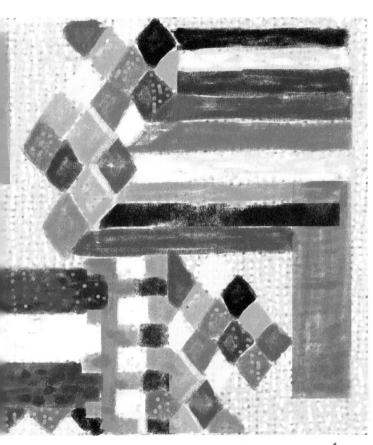

"slitweave" = gap between colors
used To create geometries & diagonals

LA BOUTIQUE DES SAINTS-PÈRES

14 Rue des Saints-Pères | 75006

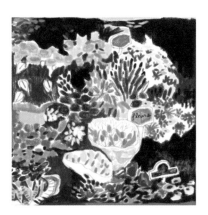

There are many sweet little flower shops in the city, and a favorite is La Boutique des Saints-Pères, where tiny bouquets and plants are on proud display in front of the handsome façade. I have sketchbooks filled with etchings of flowers, and many a pattern has emerged from these tiny discoveries.

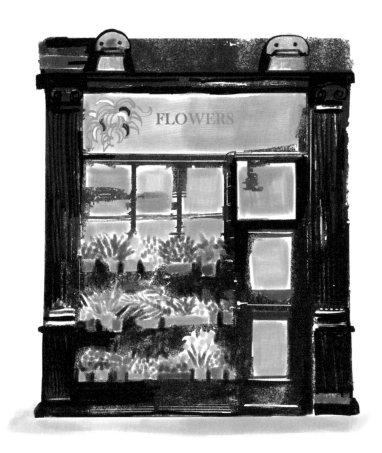

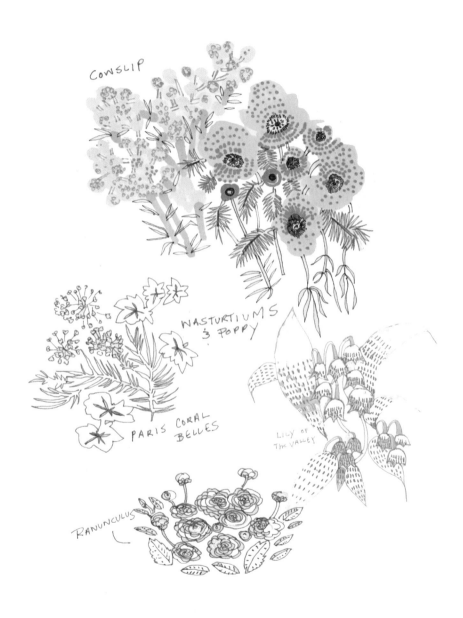

COWSLIP

WASTURTIUMS
3 POPPY

PARIS CORAL
BELLES

LILY OF
THE VALLEY

RANUNCULUS

52

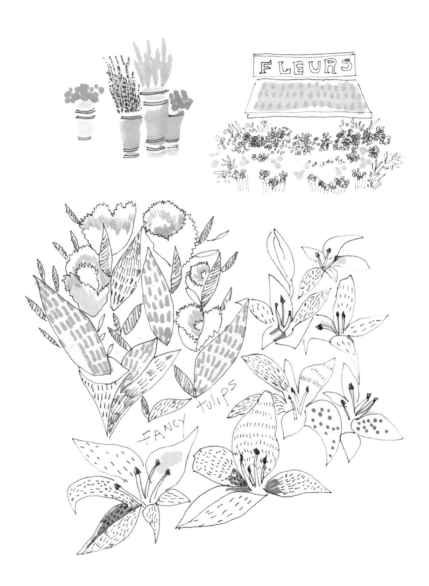

FLEURS

FANCY tulips

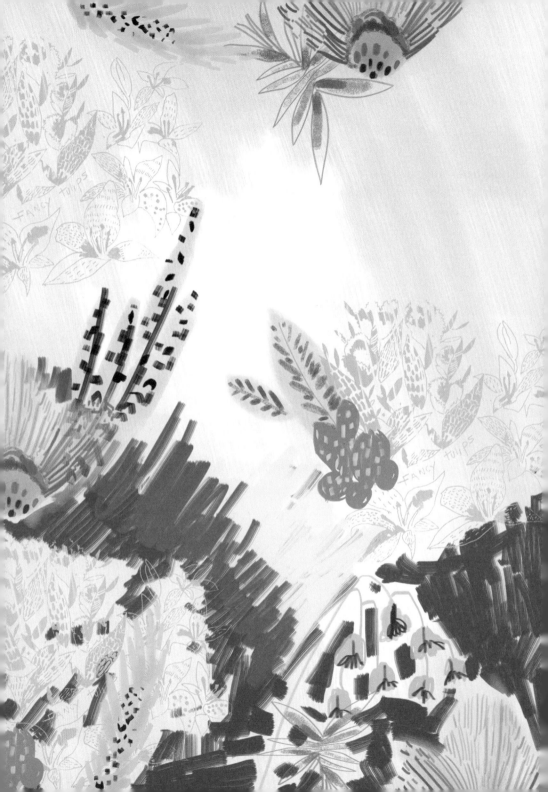

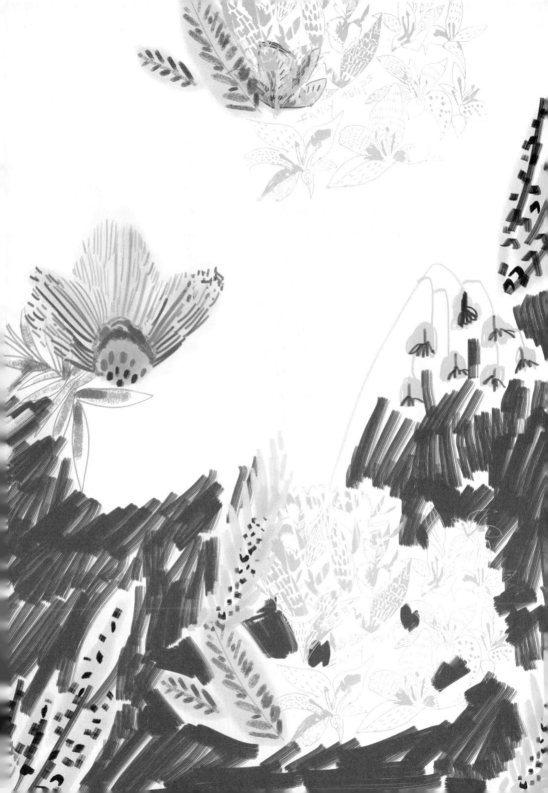

SADAHARU AOKI

35 Rue de Vaugirard | 75006

One of my favorite creations by patissier Sadaharu Aoki are his cakes, namely the bamboo cake with its matcha joconde biscuit and cream. They hold forest and tea leaf tones and carry a striking confluence of organic and geometric patterns.

RIGHT: The sleek and delectable design of the cakes inspire many a pattern....

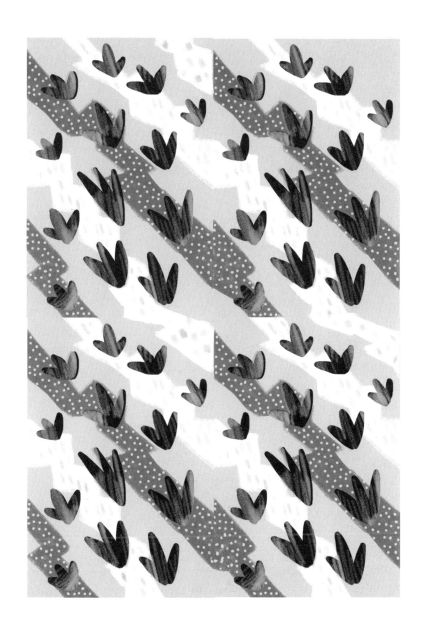

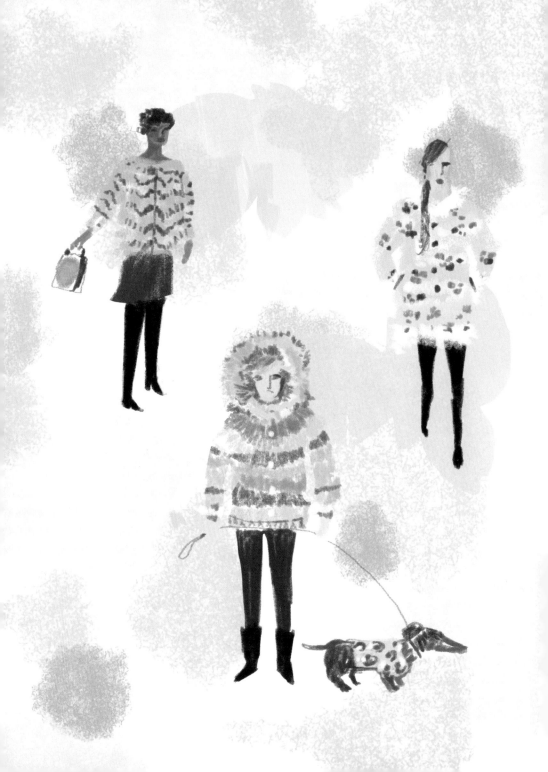

THE OVERSIZED FUR

Parisian women taught me the chic yet
comfortable essence of the oversized
coat. Patterned furs can be spotted both
day and night, from leopard to chevron
to green-and-apricot-tinted abstractions.

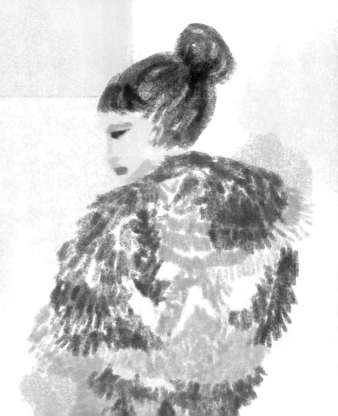

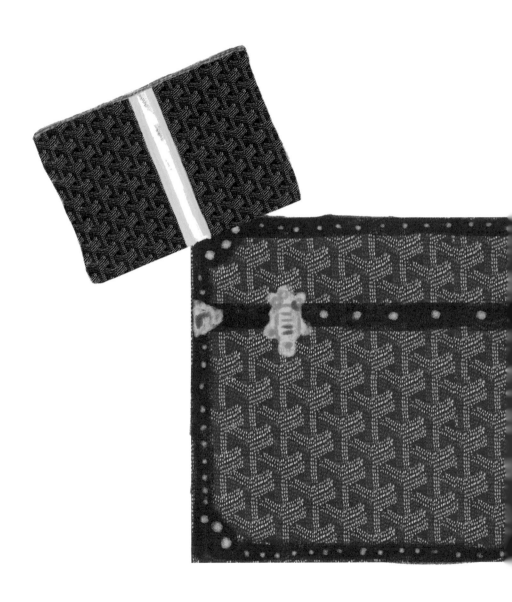

GOYARD

233 Rue Saint Honoré | 75001

I hold my breath whenever I pass the windows of
Goyard. A timeless pattern fit for a voyage . . . and for
royals, apparently. The Goyard collection spans back
to Louis XVI. But you can see urban Parisiennes young
and old with Boeings, Saint Louis totes, and oversized
clutches. Goyard's geometric pattern is iconic, but
what makes it even more special is the ability to
have your bag customized with bright stripes and
monograms. The only symbol that will be declined is
a crown, which has been reserved for members of
approved royal families.

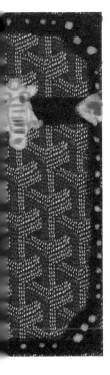

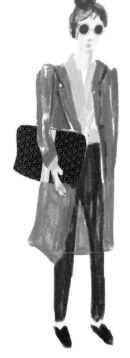

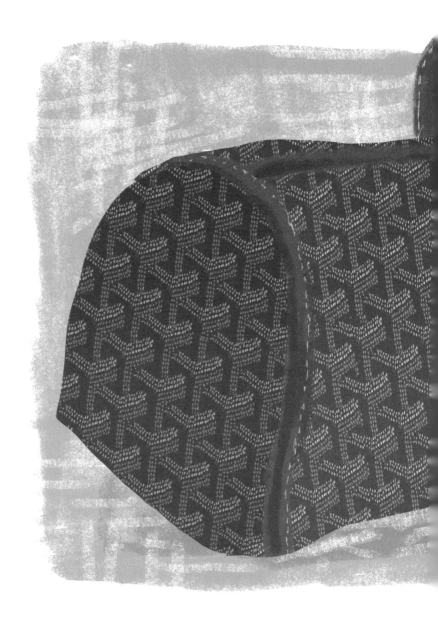

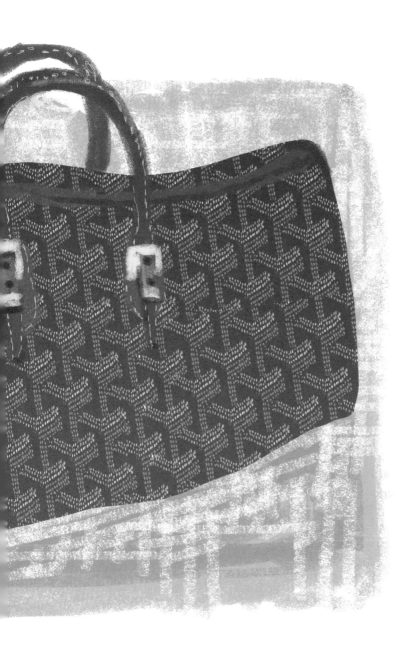

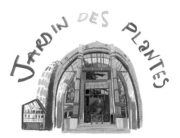

57 Rue Cuvier | 75005

I was going to visit the Jardin des Plantes for only
a few minutes. I instead spent days there, sketch-
ing among all the wanderers, art students, and
schoolchildren. We politely took up little vestiges
within the tropical environment. I spiraled up a
stone dome to look down upon black water and
a group of golden-dappled fish. I then spent the
remainder of my time inspecting and sketching
endless numbers of plant species on the grounds,
which turned into a series of botanical patterns.

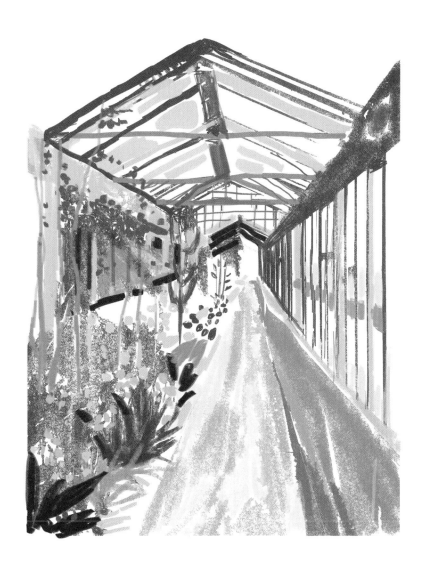

There was something truly comforting
being inside of the greenhouses.

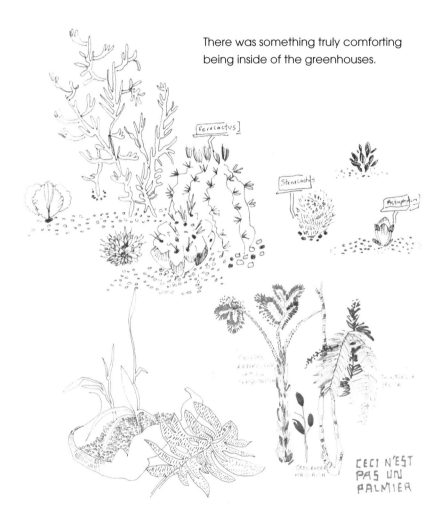

Ferocactus

Stenocactus

Astrophytum

CECI N'EST
PAS UN
PALMIER

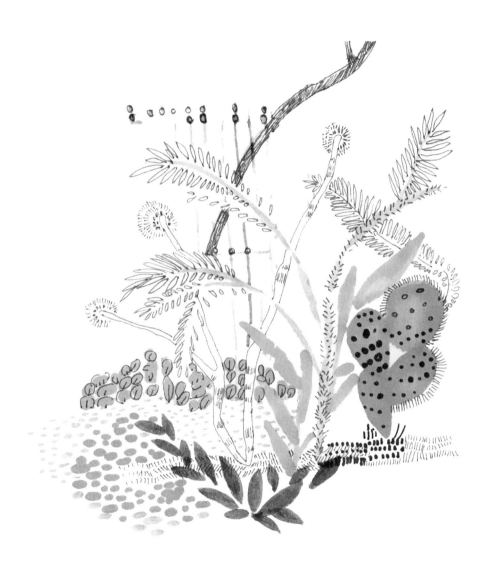

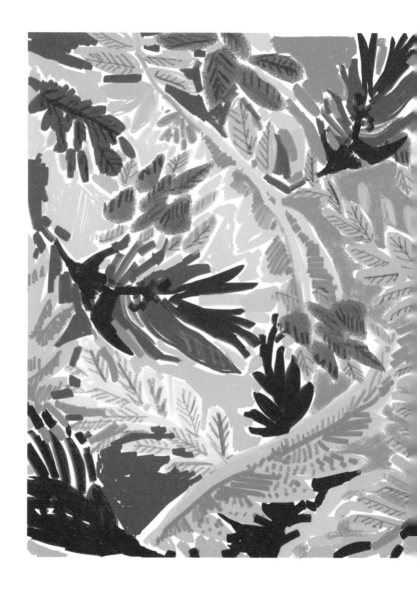

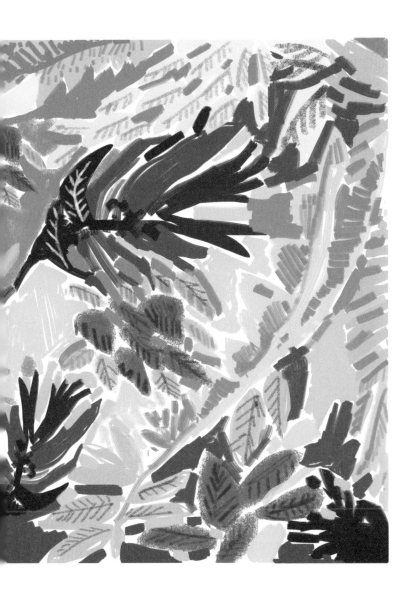

LE PAVILLON DES CANAUX

39 Quai de la Loire | 75019

There is an upbeat but casual eclecticism to this café's décor. Upstairs the space remains very much domestic, with a kitchen, bedrooms, and a bathroom with a claw-foot tub, which patrons can recline in while eating or sipping coffee. There are patterns on the floors and the staircase, but by far the most interesting pattern was on its ever-changing façade, which I could spot from a distance on the canal.

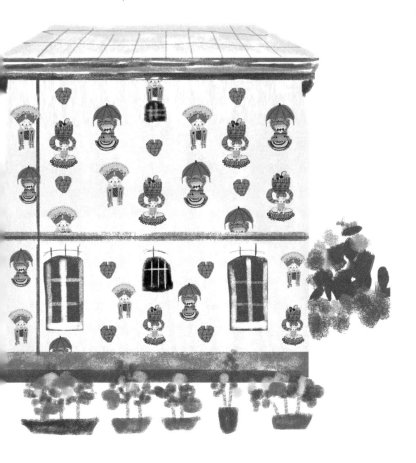

FLOOR TILES

hexagonal carreaux de ciment

OB-LA-DI CAFÉ

54 Rue de Saintonge | 75003

Count on Parisians to bring beauty up from the floors. One of my all-time favorite patterns is the classic and bold hexagonal carreaux de ciment. It weathers perfectly with age. Another favorite geometric beauty are the tiles used in one of the city's newer coffee shops, Ob-La-Di café.

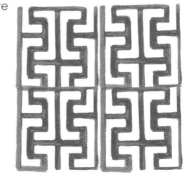

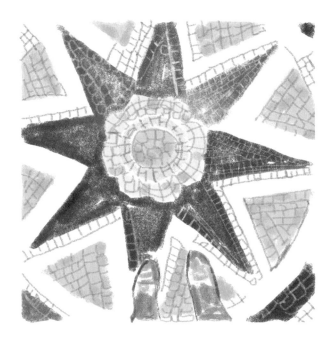

GALERIE VIVIENNE

4 Rue des Petits Champs | 75002

The passage of Galerie Vivienne is filled with intricate mosaics and tiled floors. When the sunlight comes in through the atrium the floors glimmer and reflect the soft light.

RIGHT: Septime is one of the city's most celebrated neo-bistros, with the absolute perfect floor tiles to accompany their dishes.

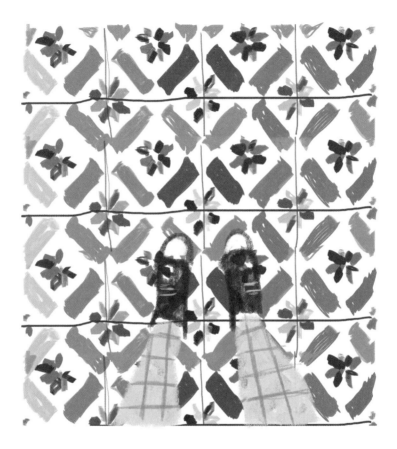

SEPTIME

80 Rue de Charonne | 75011

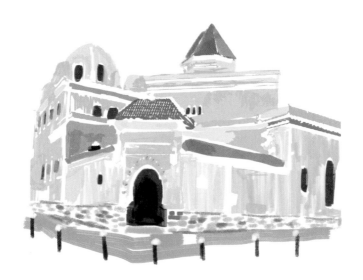

LA GRANDE MOSQUÉE DE PARIS

2bis Place du Puits de l'Ermite | 75005

The courtyards of the Grand Mosque are filled with intricate mosaic tiling that I could not help but run my fingers over. While the exterior is austere, with only a hint of tiling on the roof, it is within the confines of its serene North African– and Spanish-inspired courtyard that the delightful details come alive.

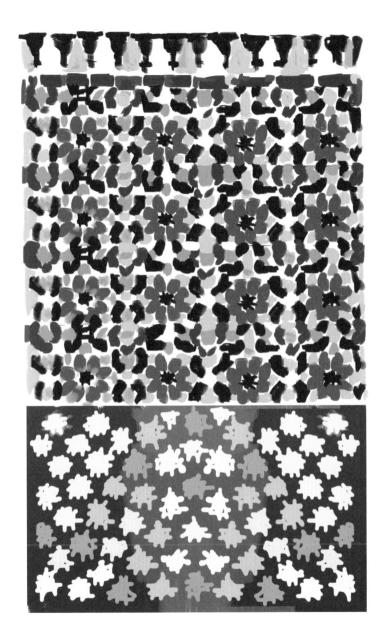

MARCHÉ DES ENFANTS ROUGES

39-41 Rue de Bretagne | 75003

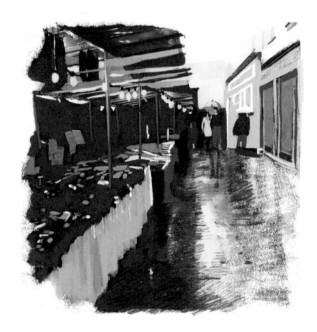

It was a rainy day at Le Marché des Enfants Rouges, which made the consumables at the market, like oranges, herring, and bunches of ranunculur, glow. There were slashes of light coming in through the tents. The striated rain and the muddled walks bounced off my feet as I walked the market on this beautiful, rainy Paris afternoon. How could these sensory and visual delights not inspire a pattern. . . .

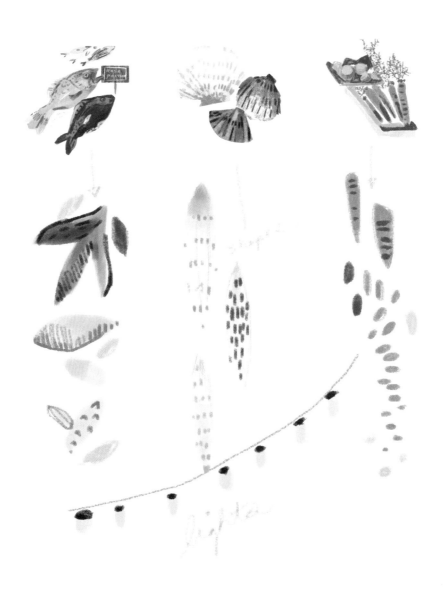

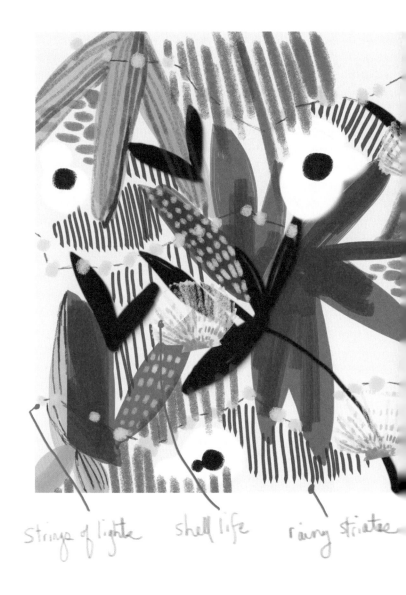

strings of lights shell life rainy striates

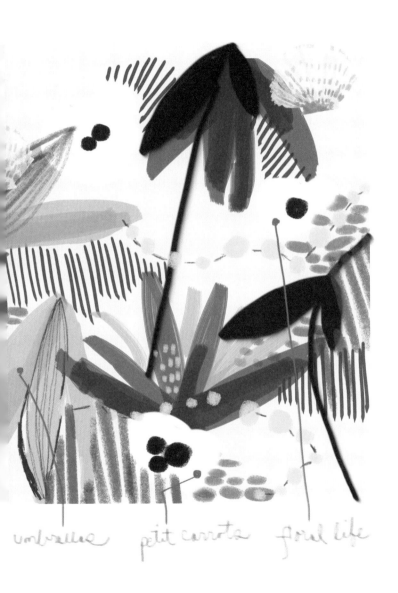

umbrellas petit carrots floral life

PERSPECTIVE

A visual technique
to achieve three-dimensional quality.
The most common types of perspective
are one-, two-, and three-point. In
one-point, the vanishing point is in the
horizon, such as a front-facing road,
which narrows at the end. Two-point
contains two vanishing points and
can be rendered by drawing the corner
of a box or building. Three-point can
best be described as an aerial
or bottom-up view.

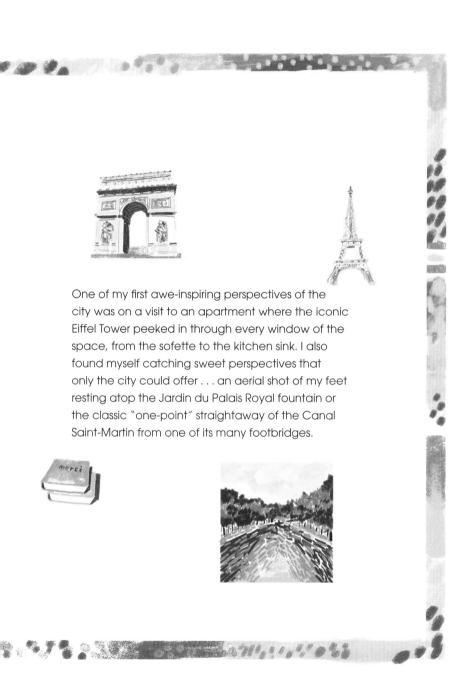

One of my first awe-inspiring perspectives of the
city was on a visit to an apartment where the iconic
Eiffel Tower peeked in through every window of the
space, from the sofette to the kitchen sink. I also
found myself catching sweet perspectives that
only the city could offer . . . an aerial shot of my feet
resting atop the Jardin du Palais Royal fountain or
the classic "one-point" straightaway of the Canal
Saint-Martin from one of its many footbridges.

MONT BLANC

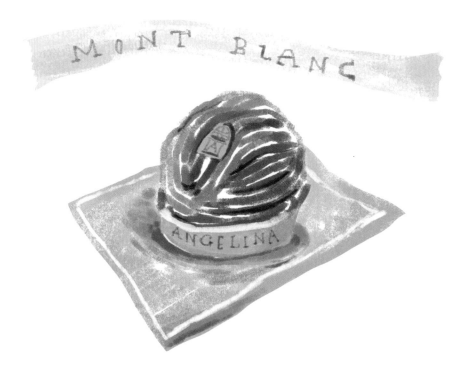

There are always two main objectives for me when visiting
Angelina: the Mont Blanc and the renowned chocolat chaud.
The Mont Blanc is a dome of meringue piped with laces of
chestnut cream that I have never fully finished in one sitting.
And while some may call chocolat chaud a drink, it is
truly an indulgent dessert for me and a welcome friend on
a cold, wintry day.

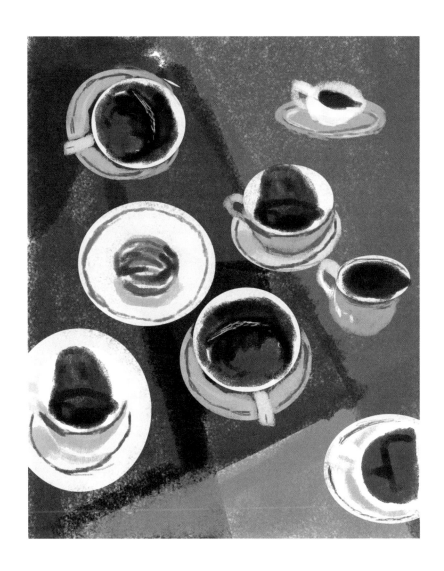

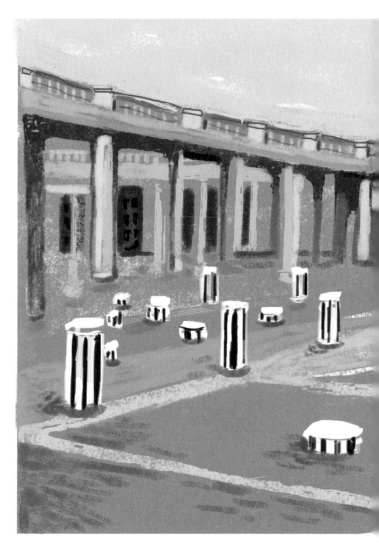

LES DEUX PLATEAUX

8 Rue De Montpensier | 75001

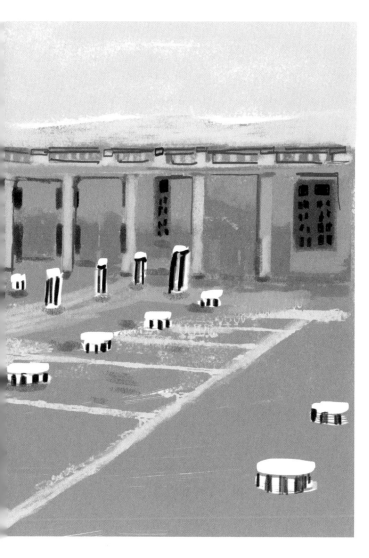

Art installation by artist Daniel Buren
within the courtyard of the Palais Royal

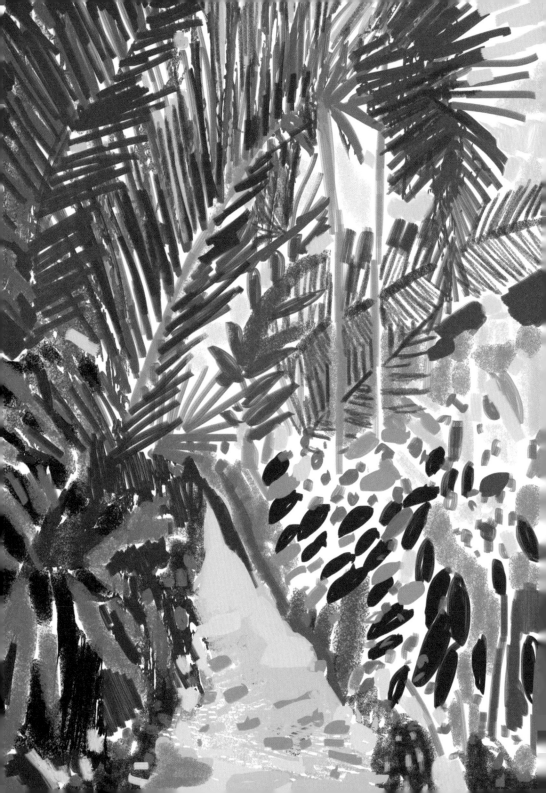

BOTANICAL GARDENS

57 Rue Cuvier | 75005

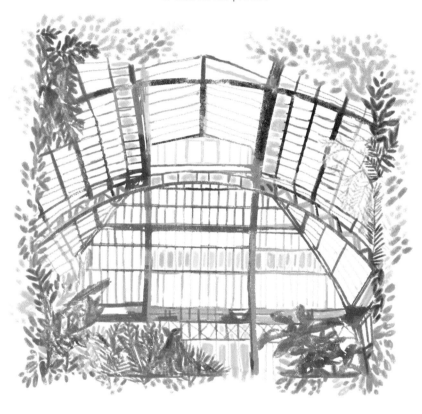

There were great perspectives within the hothouses at the Jardin des
Plantes. I found myself delightfully lost in the narrow corridors with my
sketchbook. When I needed a visual break from the density of plants,
I would look up at the stunning grid work of the glass roof.

EIFFEL TOWER

Champ de Mars, 5 Avenue Anatole France | 75007

The Eiffel Tower is an iconic symbol and a monogram for me.
This only crystallized when I glimpsed it throughout my wanderings
in the city . . . from the park, on a picnic, in between rafters, and
from the windows of many apartments. The tower is perfectly,
if not dramatically, framed by the city everyday.

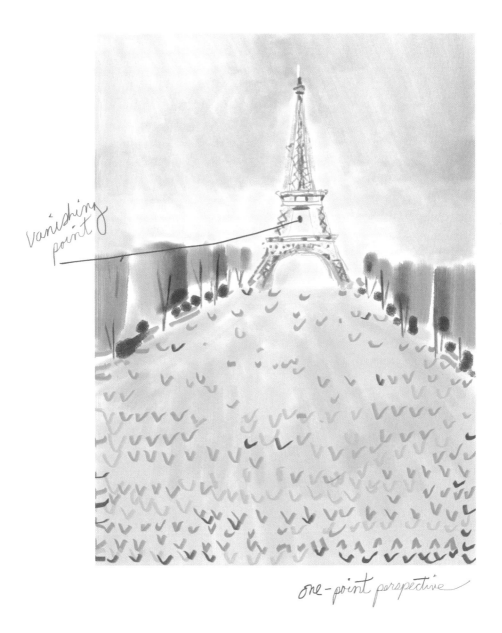

vanishing point

one-point perspective

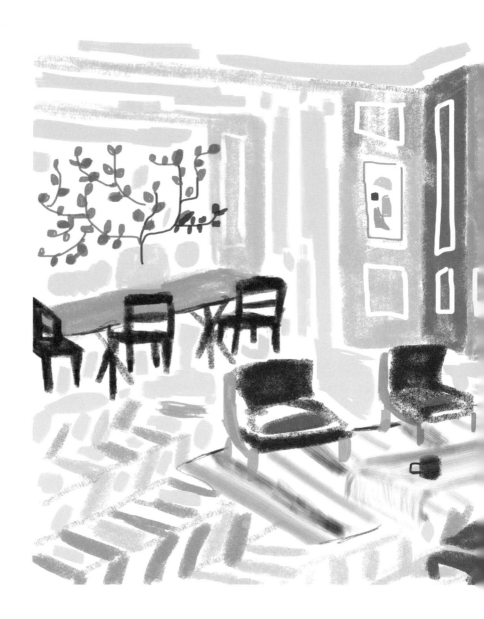

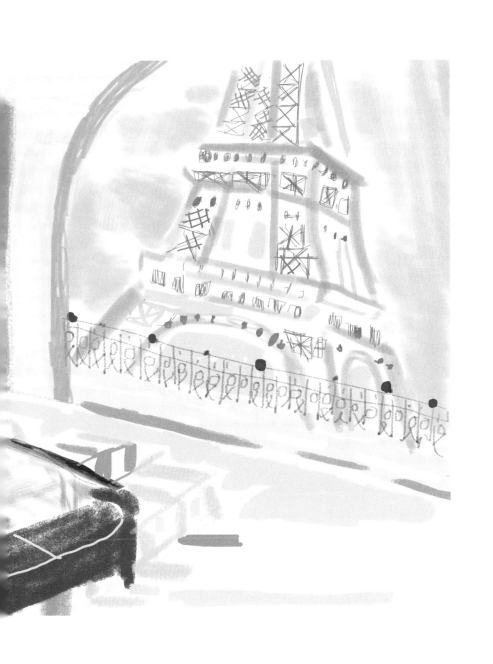

MERCI USED BOOK CAFÉ

111 Boulevard Beaumarchais | 75003

There is a slow curve to the wall of books within
this beautiful space. The height and narrowness
of the café is brought to intimate life when patrons
are found dotted along the walls, almost buried
in their coffee and daily rituals.

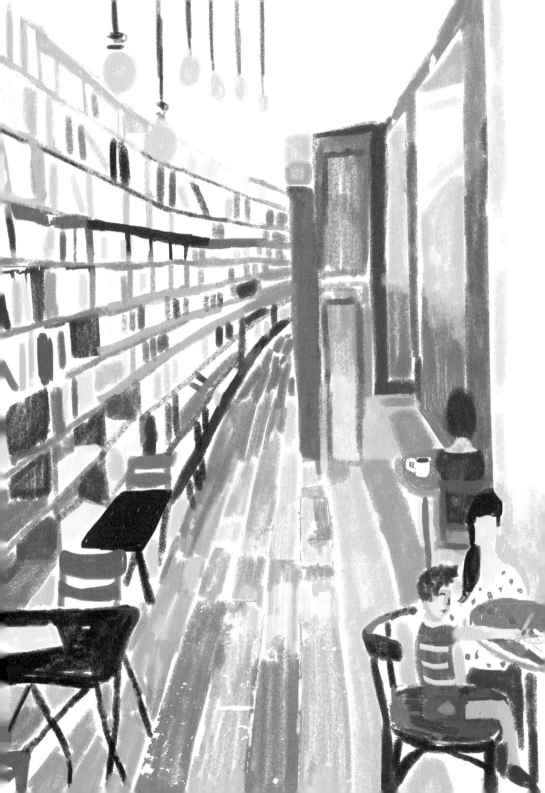

MERCI INTERIOR

GRANDE GALERIE D'EVOLUTION

36 Rue Geoffroy-Saint-Hilaire | 75005

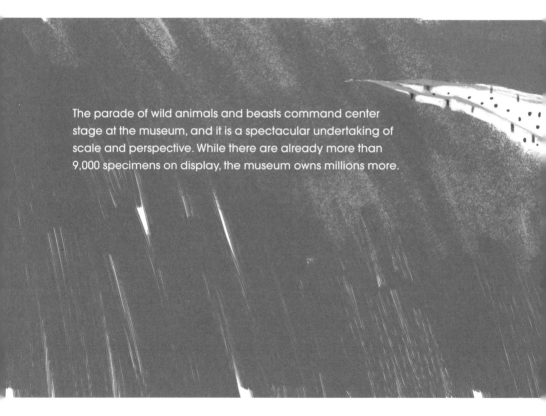

The parade of wild animals and beasts command center stage at the museum, and it is a spectacular undertaking of scale and perspective. While there are already more than 9,000 specimens on display, the museum owns millions more.

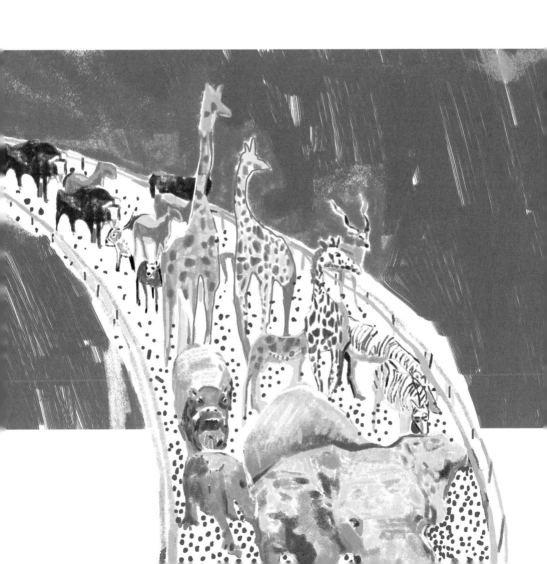

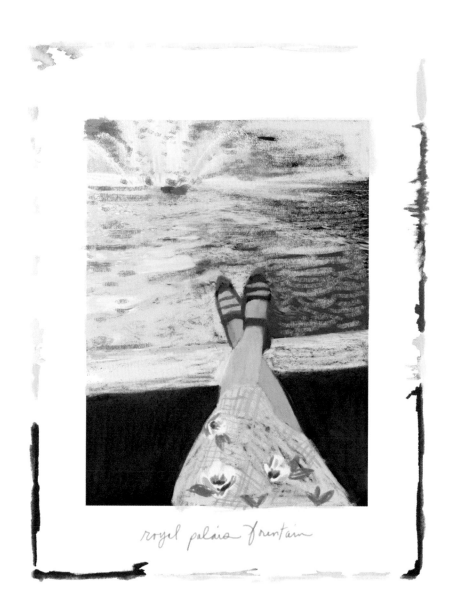

royal palais fountain

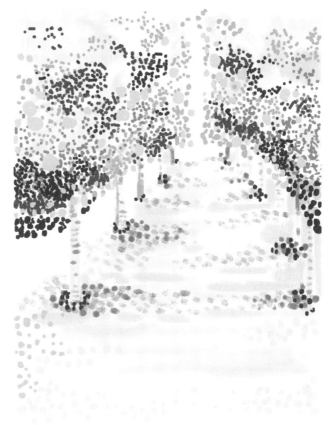

Perspective study at the Jardin Royal Palais

JARDIN DU PALAIS ROYAL

6 Rue de Montpensier | 75001

LEFT: I caught myself happily lazing around the fountain on Bastille Day.

ABOVE: An attempt to capture the seam of light that runs atop the trees and along the arcades. I also wanted to try and portray the crunch of the stone gravel underfoot through dots.

THE *MONA LISA* (*LA JOCONDE*)

The Louvre Museum | 75001

To catch a glimpse of Mona is to catch a perspective of her in miniature, surrounded by her adoring fans en masse. The swell of crowds began to grow as I hurried past countless galleries of notable art to the Salles des Etus gallery, where she resides.

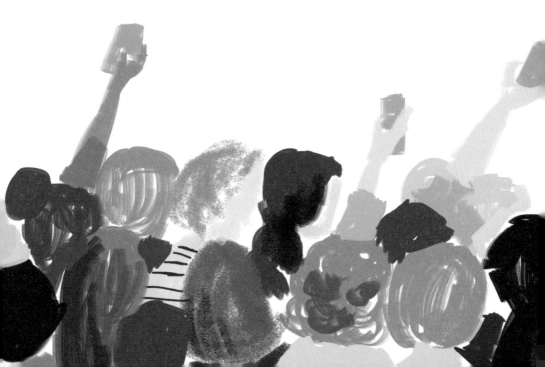

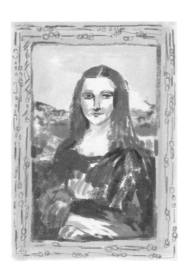
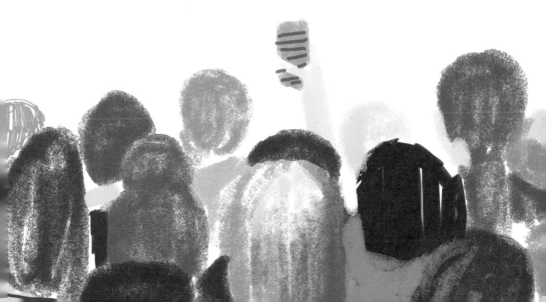

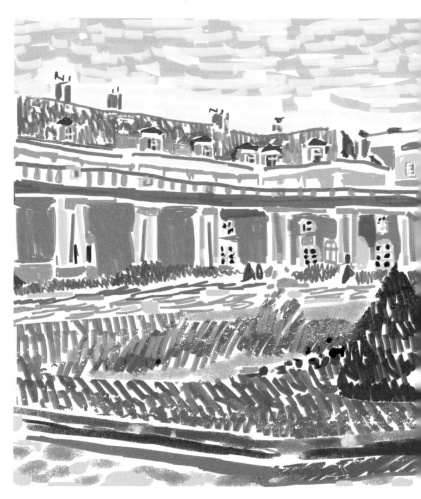

MUSÉE DES ARCHIVES NATIONALES

60 Rue des Francs Bourgeois | 75003

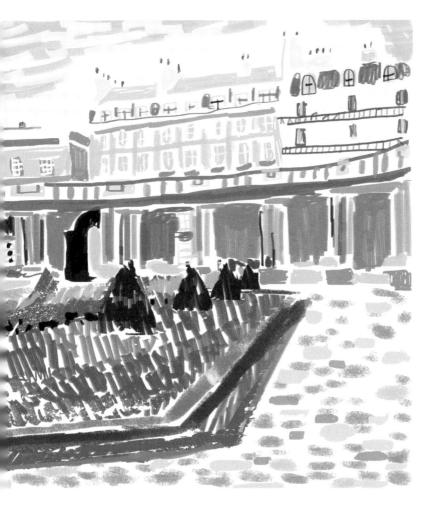

Perspectives take on grand and intimate splendor within the city's inner courtyards. The Archive Nationales opens up for the public to come stroll around the gardens, while the Grand Mosque is an intimate and enchanting sanctuary.

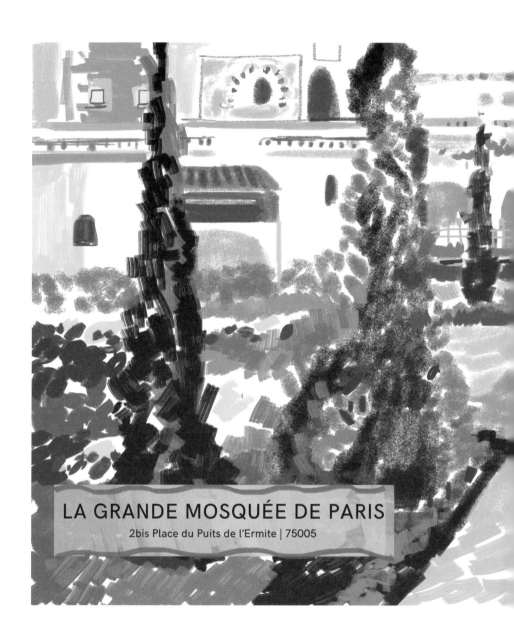

LA GRANDE MOSQUÉE DE PARIS

2bis Place du Puits de l'Ermite | 75005

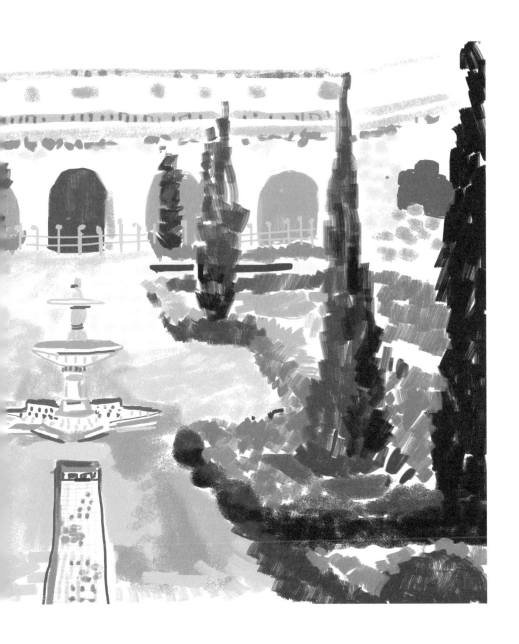

JARDIN LE POTAGER
DES OISEAUX

2-4 Rue des Oiseaux | 75003

There are charming community gardens
dotted throughout the city. Jardin Potager
exists in the Marais, bearing ten plots of roses,
espaliers, and, fruits, and is always lovely to
spy upon from above neighbors' homes.

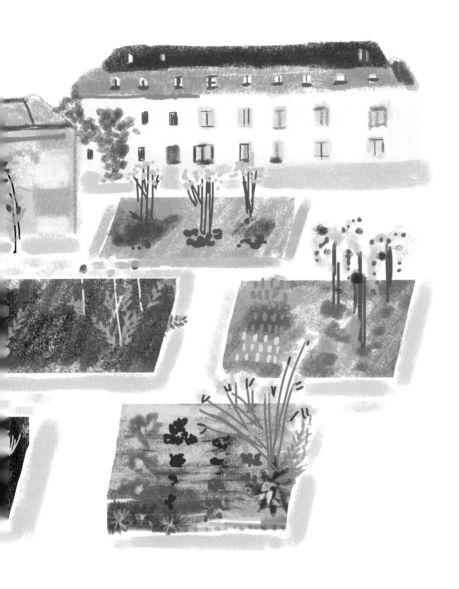

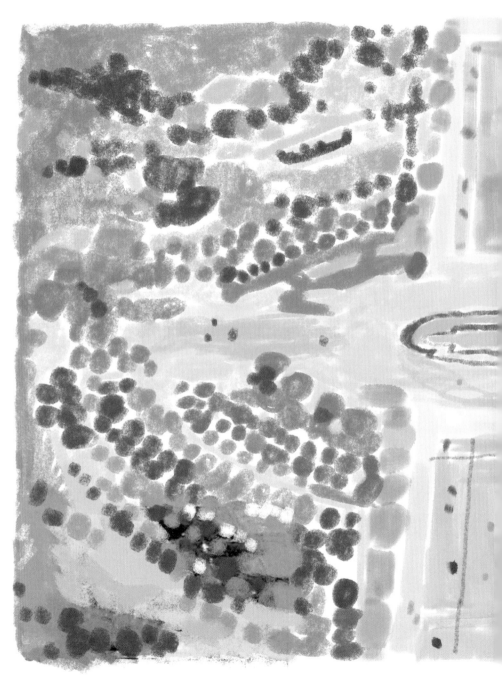

City Center Parc du Champ de Mars

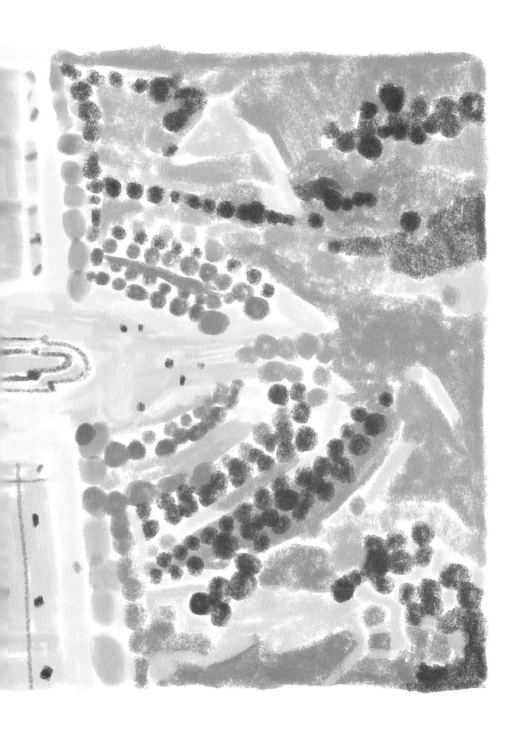

this is the museum
of quirky delights:
within austere walls:
pomp of the hunt,
taxidermy, trophy
rooms with painted
ceilings all the hue
of the French flag.

MUSÉE DE LA CHASSE ET DE LA NATURE

62 Rue des Archives | 75003

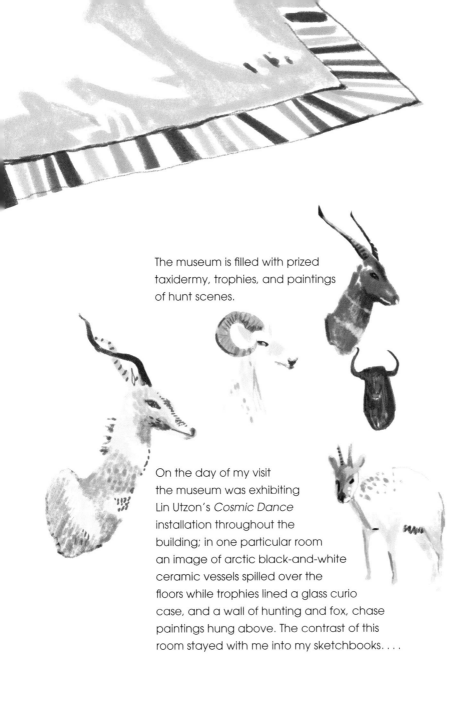

The museum is filled with prized taxidermy, trophies, and paintings of hunt scenes.

On the day of my visit the museum was exhibiting Lin Utzon's *Cosmic Dance* installation throughout the building; in one particular room an image of arctic black-and-white ceramic vessels spilled over the floors while trophies lined a glass curio case, and a wall of hunting and fox, chase paintings hung above. The contrast of this room stayed with me into my sketchbooks. . . .

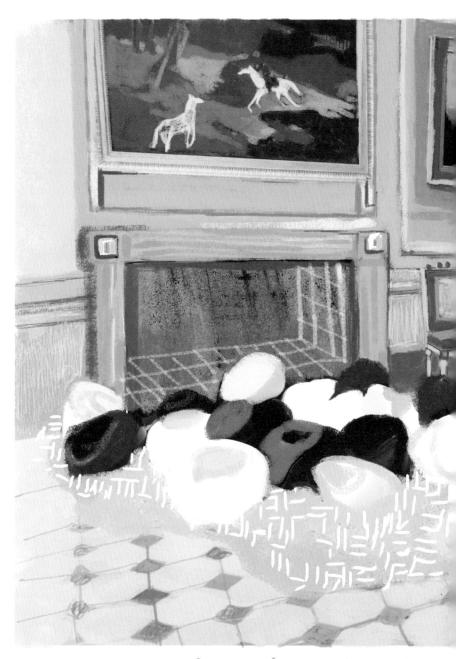

museum of hunting and nature

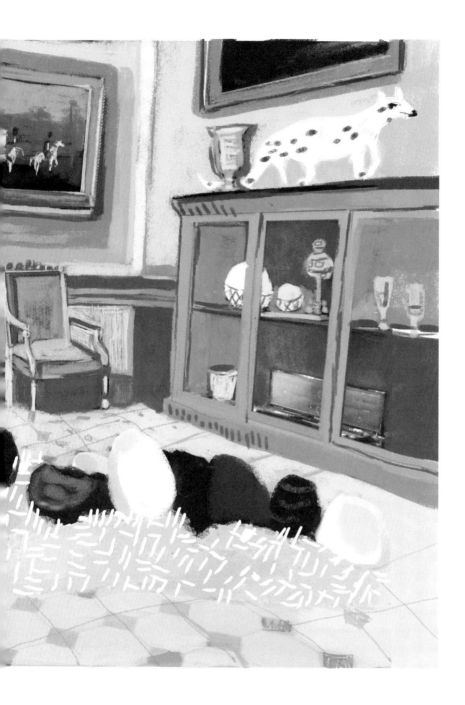

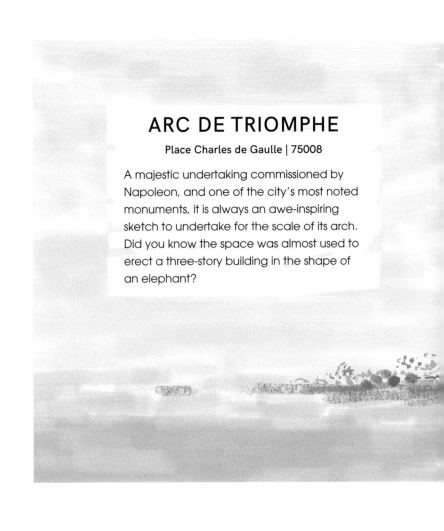

ARC DE TRIOMPHE

Place Charles de Gaulle | 75008

A majestic undertaking commissioned by
Napoleon, and one of the city's most noted
monuments, it is always an awe-inspiring
sketch to undertake for the scale of its arch.
Did you know the space was almost used to
erect a three-story building in the shape of
an elephant?

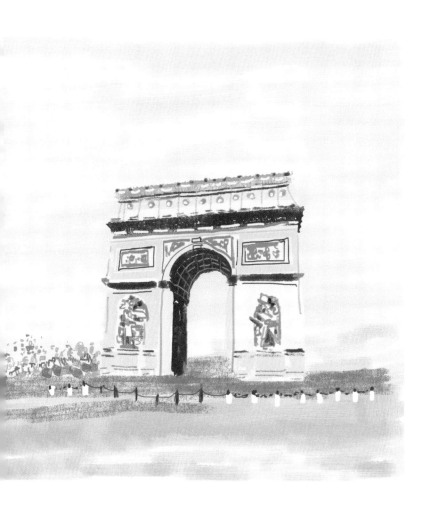

The canal is a favorite stroll of mine. There are many pedestrian bridges I love walking, where I can get a good glimpse at the narrow passages of water below and casual picnickers dotted beneath the canopy of trees. I was also fortunate enough to see the canal drained on a recent visit, which only happens every decade or so; when it does, sunken treasure, bicycles, and even an occasional stroller can be found.

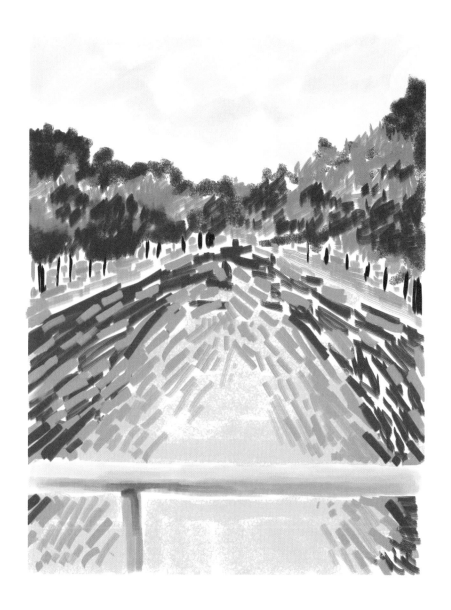

RHYTHM

Using elements of art to achieve the feeling of movement. Artists will try to evoke this visual flow or tempo through strokes, lines, color, repetition, and perspective. Rhythm can also be used as a cultural signifier and represent a time period or artistic movement.

This final chapter came about while sketching the city. I sought technical "rhythms" through the ripples in the garden fountains or cloud strokes along the Seine. But I also found myself completely overtaken by the idea of rhythm in a much broader sense. I was enthralled by the energy of Parisian city life, whether it was the ritual of a serene afternoon in a tearoom, dancing to Afro-French beats in the night, or people watching from a bistro café. Investigating rhythm could not exclude my curiosities of how a city comes to life in all its daily and celebrated rituals.

LILY OF THE VALLEY

12 Rue Dupetit-Thouars | 75003

I found myself stopping in the middle of my days to partake in the ritual of afternoon tea. A day in Paris is not complete without this pause, and I sketched many a tearoom in the city, observing the quiet stir of patrons amid both dark, opulent environments and cozy, floral backdrops. My first visit to Lily of the Valley was admittedly disappointing, as it was a particularly cold and brisk afternoon, and this feminine den was quite sought after. I breathed in the thick canopy of botanicals and florals hanging from the ceiling and quietly waited my turn while enviously admiring the long bench of girlfriends, curled up reading and gossiping for the afternoon.

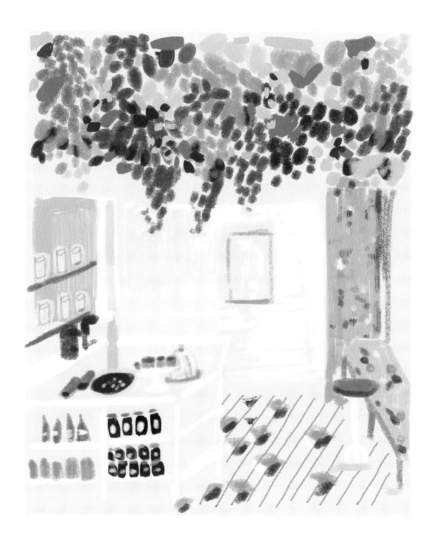

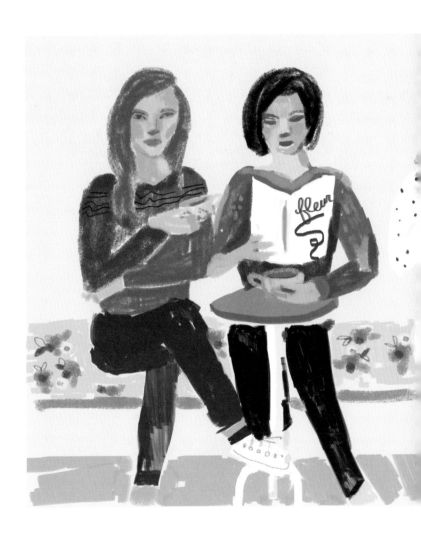

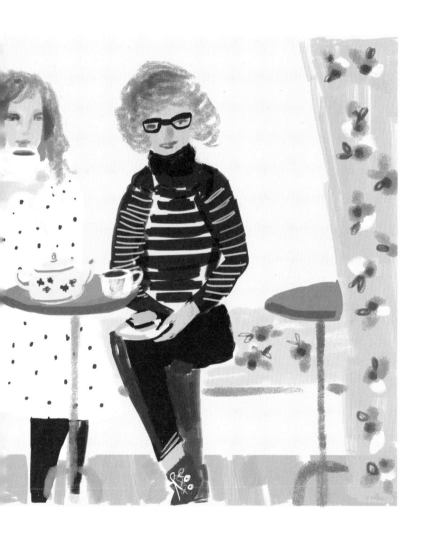

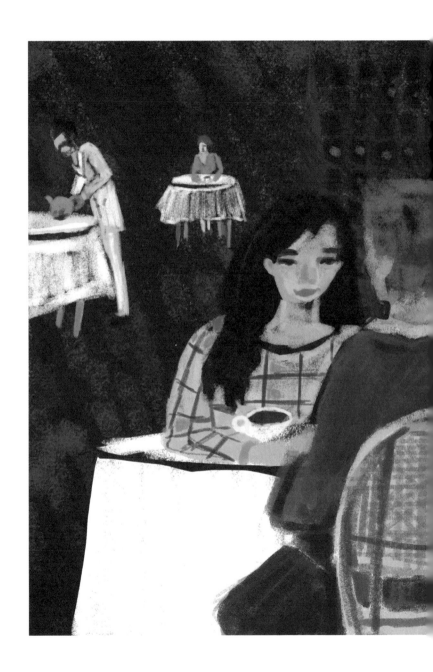

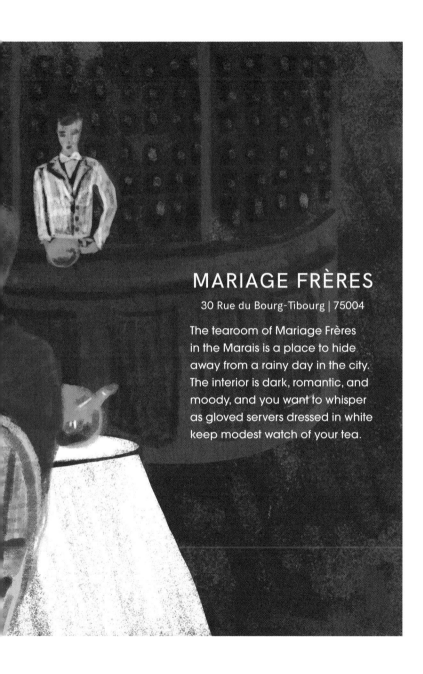

MARIAGE FRÈRES

30 Rue du Bourg-Tibourg | 75004

The tearoom of Mariage Frères
in the Marais is a place to hide
away from a rainy day in the city.
The interior is dark, romantic, and
moody, and you want to whisper
as gloved servers dressed in white
keep modest watch of your tea.

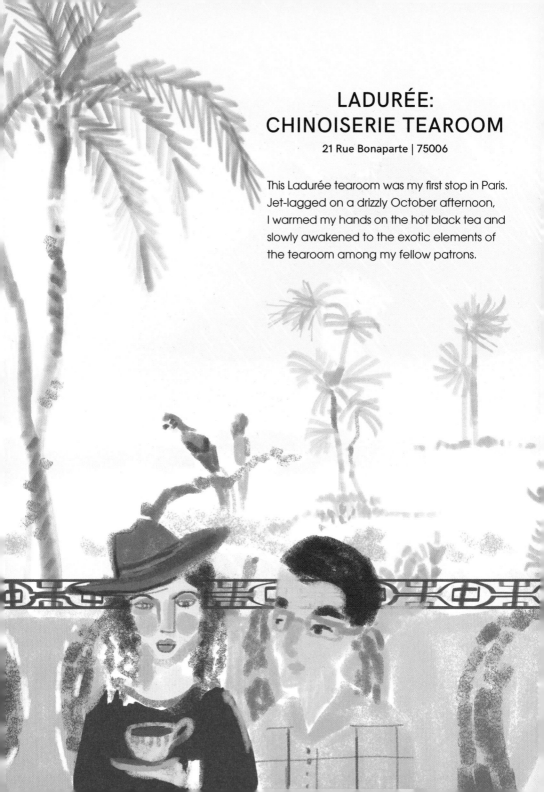

LADURÉE: CHINOISERIE TEAROOM

21 Rue Bonaparte | 75006

This Ladurée tearoom was my first stop in Paris. Jet-lagged on a drizzly October afternoon, I warmed my hands on the hot black tea and slowly awakened to the exotic elements of the tearoom among my fellow patrons.

LE BONAPARTE

42 Rue Bonaparte | 75006

The café bistro Le Bonaparte is a quintessential window into the daily rhythms of Parisian life: people watching. This is of course best done facing out, rain or shine, beneath a striped awning and against woven, rattan chairs, with a cup of coffee or a glass of wine.

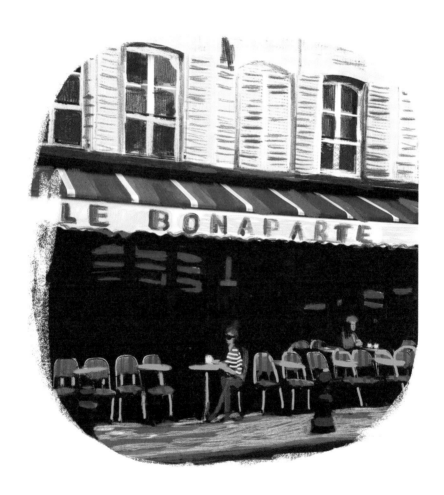

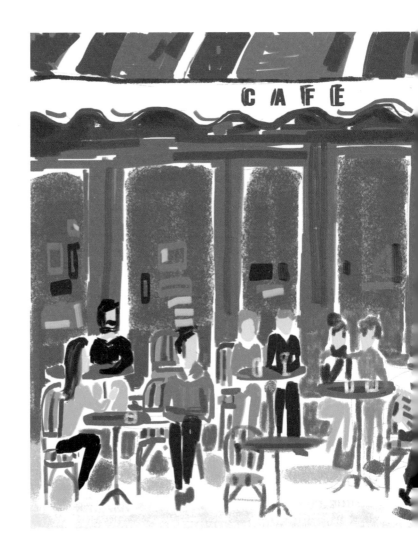

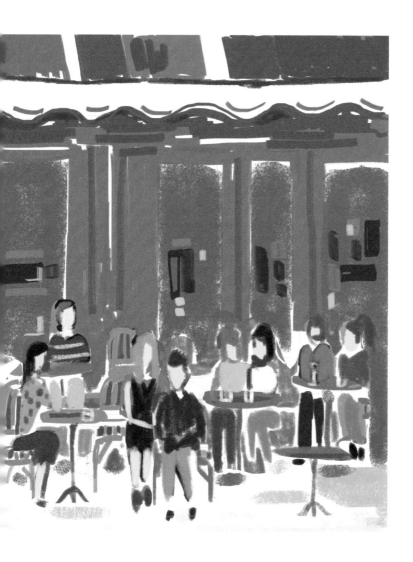

CHANEL HAUTE COUTURE SHOW

Grand Palais | 75008

The rhythm of a Paris runway show: I won't soon forget watching footage of the Spring 2015 Chanel show featuring the most incredible paper jungle at the center of its runway stage. The pale white flowers began to open and spring to life, revealing toucan hues and pops of color. As each model began her procession around the walkway, it seemed as if Karl Lagerfeld had plucked these wild colors and sewn them straight onto their ethereal skirts and bodices.

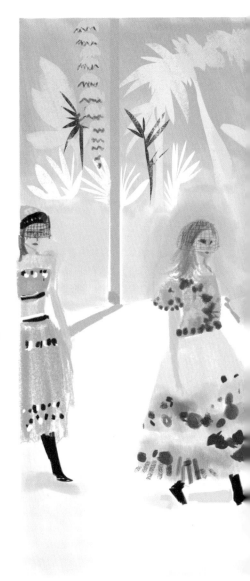

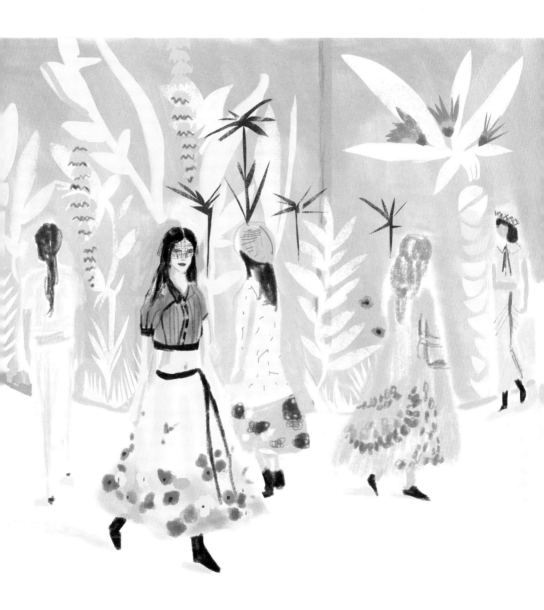

59 RIVOLI

59 Rue de Rivoli | 75001

The 30 or so artists who comprise the working studios at 59
Rivoli provide an intimate peek into the energy and rhythms
of a modern Parisian artist. On the day I visited, the façade
was adorned with cerulean hoops, and the whorl-painted
doors gave a hint of what was inside. I climbed up staircases
to each of the six floors covered in scrawled drawings and
paint drippings, following in bemusement the tail and body
of an outlined serpent. On each floor artists displayed their
works in progress. I could hear a can being clinked by a
brush and easels being pushed back before I even arrived
at the studio. They greeted me with polite "bonjours" but
quickly returned to their internal dreamscapes. I wound my
way through installations made of rubber dolls, recycled
trash, and twine, and endless cubicles of canvas paintings
and prints. There was such intense creative energy there
that could only be described as the passions of the artists.

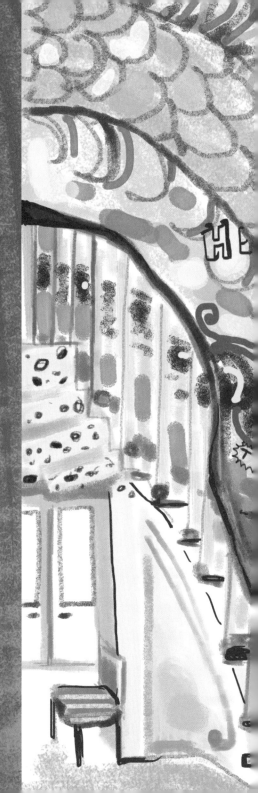

I climbed up six flights
of stairs, following the tail
of this serpentine creation.
Every inch of the walls were
covered with its scales
and the minutiae of etched
drawings, monograms,
and layered patterns.

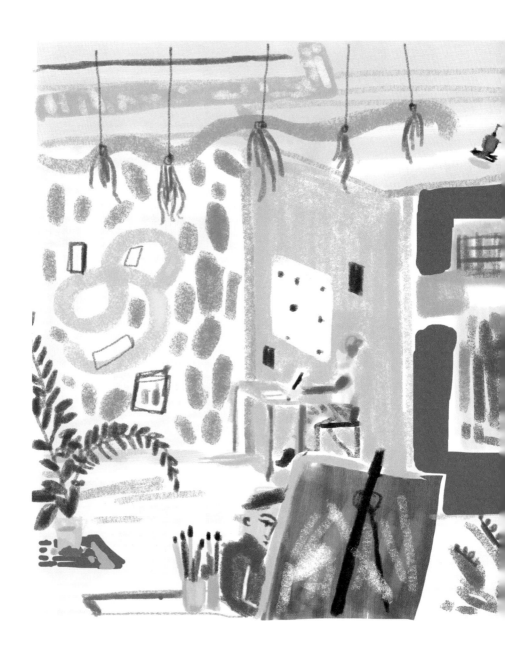

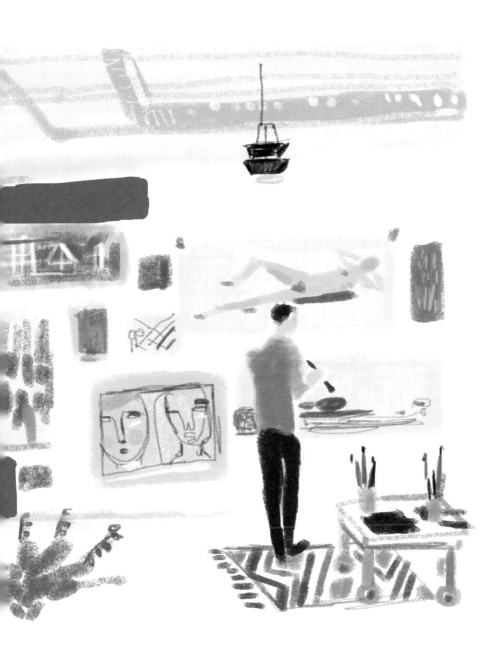

CITY DOGS

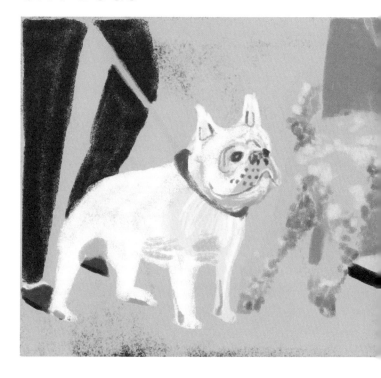

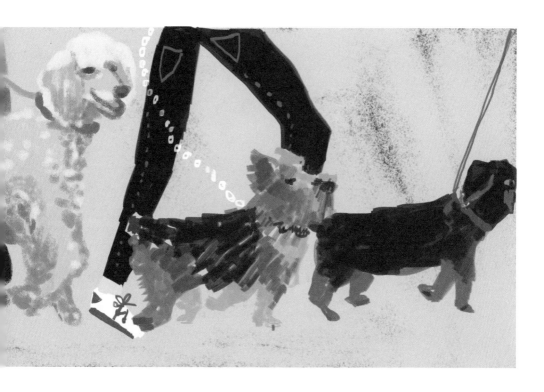

How could a city's rhythm not include the flurry and patter of its four-legged residents? Parisian dogs proudly accompany their owners throughout the city and are equal parts energetic and civilized while navigating through Saint-Germain's narrow cobbled streets or the busy Champs-Élysées.

LE COMPTOIR GÉNÉRAL

80 Quai de Jemmapes | 75010

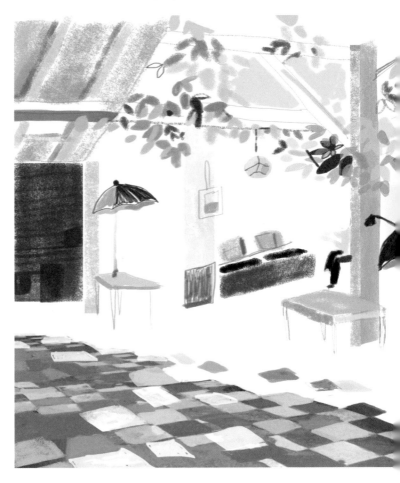

BY DAY

By day the Comptoir Général is an airy, meandering set of rooms found through a narrow alleyway. It is one of my favorite places in the city to let my imagination wander. It simultaneously serves as a museum of Francophone Africa and the Caribbean, a watering hole and cantina, a coffee stand, and even a children's classroom.

LE COMPTOIR GÉNÉRAL

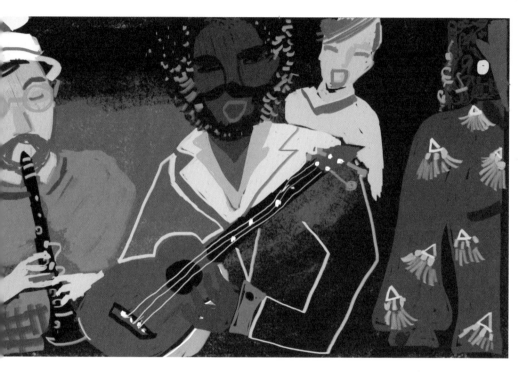

BY NIGHT

By night the soft wood floors vibrate to the sounds of music
and reveling guests.

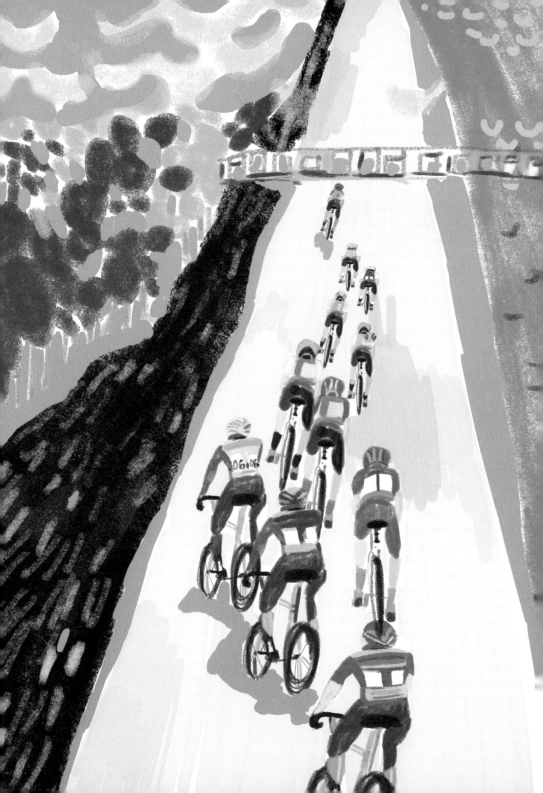

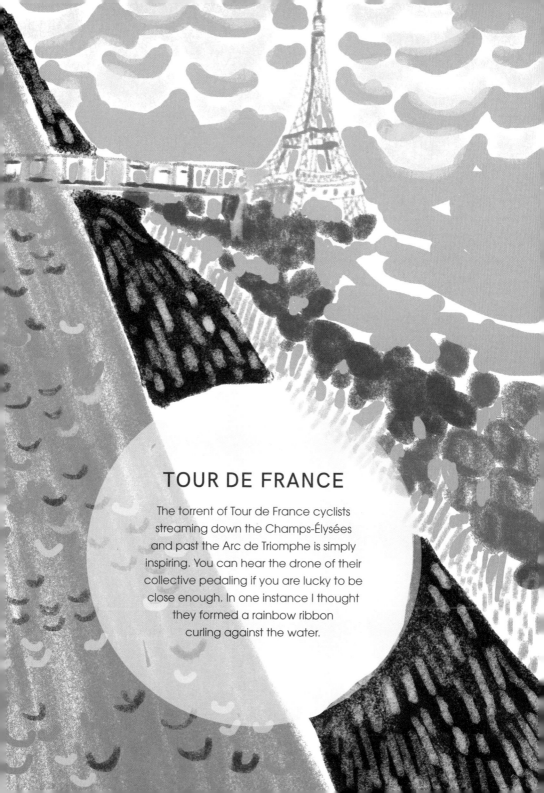

TOUR DE FRANCE

The torrent of Tour de France cyclists
streaming down the Champs-Élysées
and past the Arc de Triomphe is simply
inspiring. You can hear the drone of their
collective pedaling if you are lucky to be
close enough. In one instance I thought
they formed a rainbow ribbon
curling against the water.

84 Rue de Varenne | 75007

Alain Passard began his odyssey with food when, at ten years old, he apprenticed for a chef, absorbing the "rhythm and activity of the laboratory and the evocative qualities of aromas." With three Michelin stars under its belt, Arpège is considered one of the best restaurants in the world.

It was dusk, and the taxi paused in front of a discreet doorway, which was lit from within. A silhouette of a woman appeared and ushered me in while the rest of the waitstaff perched, on the lookout for the arrival of other patrons. Little did I know I would soon be whisked into the culinary orchestration of Alain Passard and his team. The rhythm of timing of the multicourse vegetable-based dishes took on a symphonic quality. Little dumpling gems floated in a clear broth. A turbot swooped in on display for all to see. A mosaic of thinly sliced scallops arrived like a piece of artwork. Mr. Passard came to bid adieu to each patron at the end of the meal, which felt more like a bow to an unforgettable culinary performance.

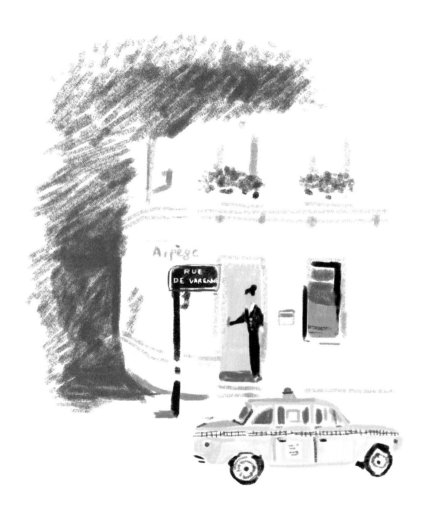

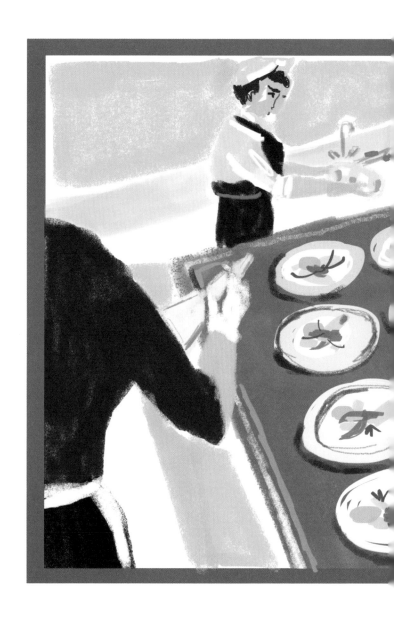

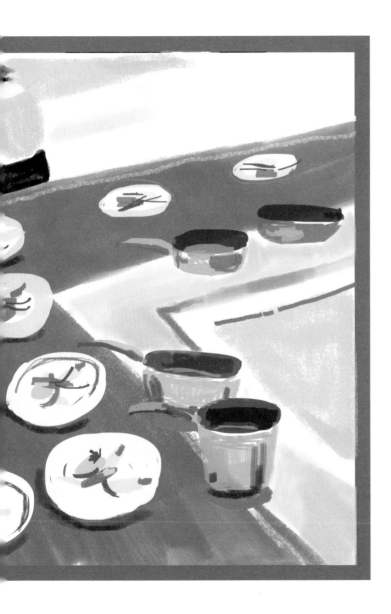

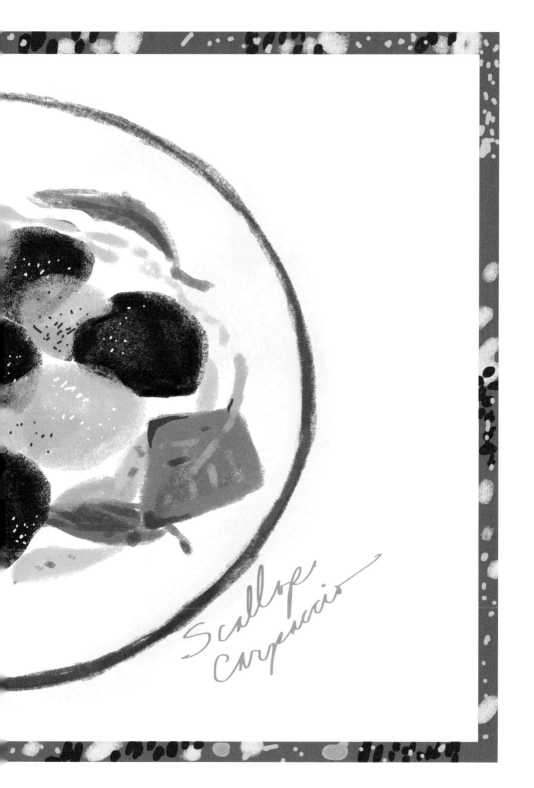

Scallop
Carpaccio

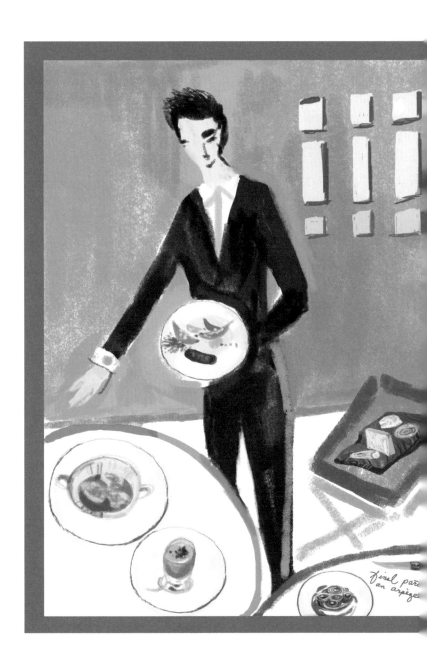

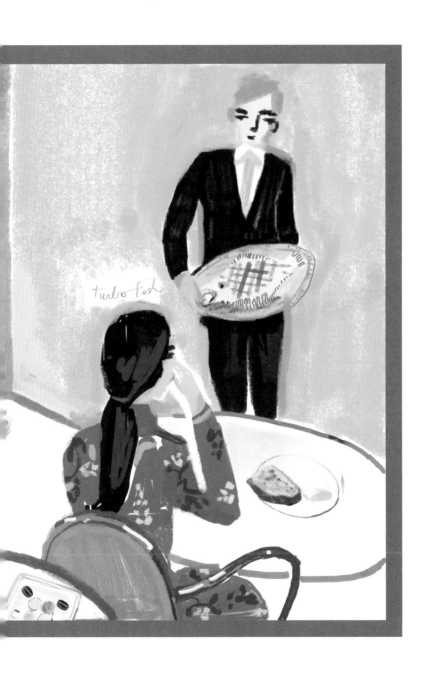

turbo fish

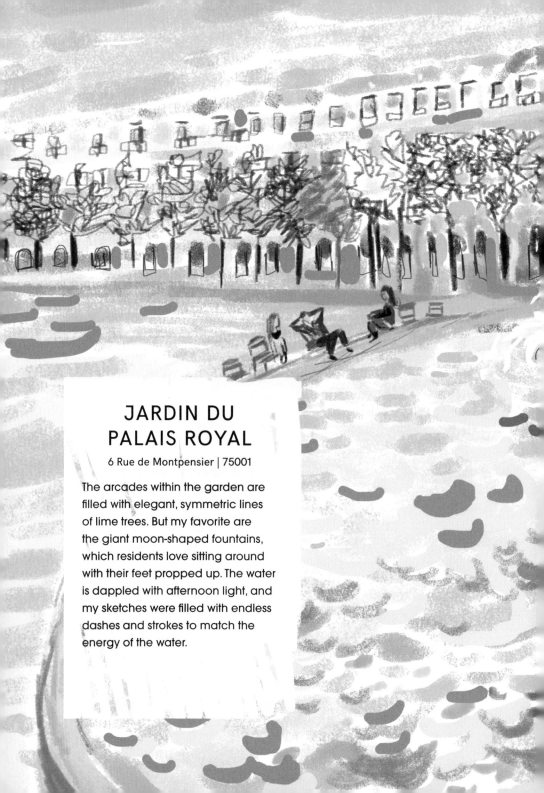

JARDIN DU PALAIS ROYAL

6 Rue de Montpensier | 75001

The arcades within the garden are filled with elegant, symmetric lines of lime trees. But my favorite are the giant moon-shaped fountains, which residents love sitting around with their feet propped up. The water is dappled with afternoon light, and my sketches were filled with endless dashes and strokes to match the energy of the water.

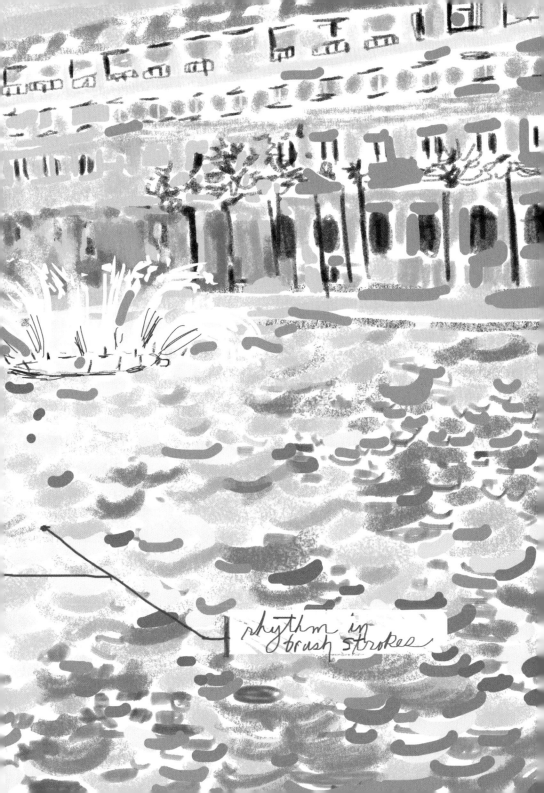

rhythm in brush strokes

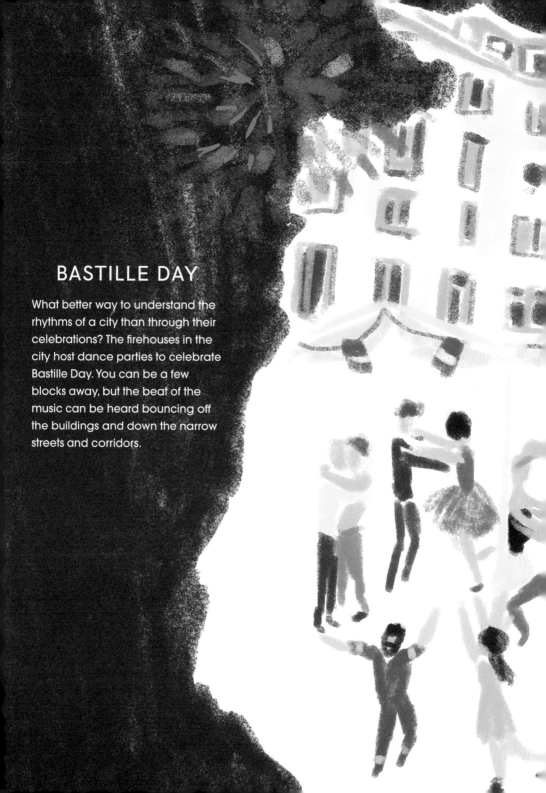

BASTILLE DAY

What better way to understand the rhythms of a city than through their celebrations? The firehouses in the city host dance parties to celebrate Bastille Day. You can be a few blocks away, but the beat of the music can be heard bouncing off the buildings and down the narrow streets and corridors.

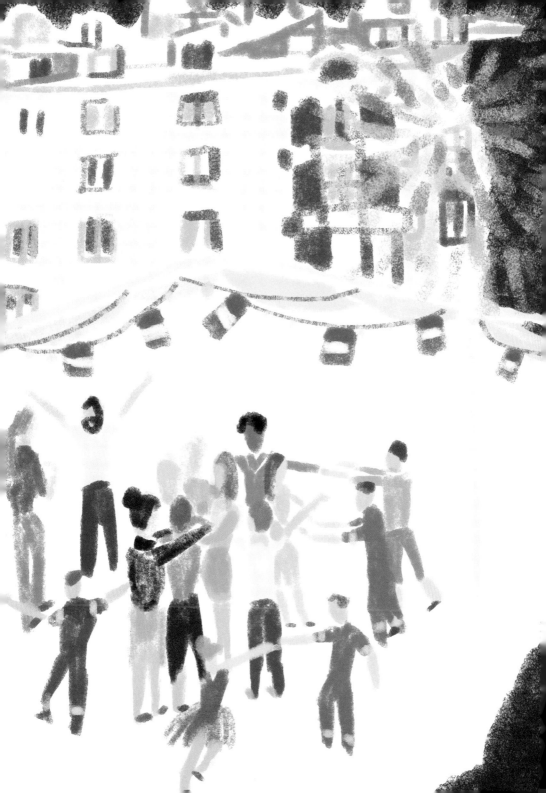

le pavillon de la Fontaine

ACKNOWLEDGMENTS

This book has been nothing short of a dream to illustrate and write. I would like to give heartfelt thanks to those who helped make this possible: to my agent Kate Woodrow for your unwavering vision and confidence in me; my editor Becca Hunt for your positive and expert support in shepherding this book through while letting me loose on the streets of Paris. Thank you, Monique Pritchett for your sincere dedication, assistance, and being an example to young individuals of good work ethic. And I cannot conclude without thanking "RB" for an unforgettable constellation of introductions, awakenings, and journeys into Paris and beyond.

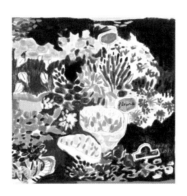

IMPRESSIONS OF PARIS

HarperCollins books may be purchased for educational, business, or sales promotional use. For information please e-mail the Special Markets Department at SPsales@harpercollins.com.

Published in 2017 by
Harper Design
An Imprint of HarperCollins *Publishers*
195 Broadway
New York, NY 10007
Tel: (212) 207-7000
Fax: (855) 746-6023
harperdesign@harpercollins.com
www.hc.com

Distributed throughout the world by
HarperCollins *Publishers*
195 Broadway
New York, NY 10007

ISBN 978-0-06-249307-1

Library of Congress Control Number 2016939742

Printed in China

First Printing, 2017

ABOUT THE AUTHOR

Cat Seto is a San Francisco–based illustrator, designer, and author. Her French-inspired paper goods collection, Ferme à Papier, is sold in boutiques, museums, and bookshops around the country. She holds a BFA in painting and an MFA in fiction from the University of Michigan.